French Cinema Since 1950

French Cinema Since 1950

Personal Histories

Emma Wilson

Duckworth

First published in 1999 by
Gerald Duckworth & Co. Ltd.
61 Frith Street, London W1V 5TA
Tel: 0171 434 4242
Fax: 0171 434 4420
Email: enquiries@duckworth-publishers.co.uk

© 1999 by Emma Wilson

A catalogue record for this book is available
from the British Library

ISBN 0 7156 2849 6

Typeset by Derek Doyle & Associates
Mold, Flintshire
Printed in Great Britain by
Page Bros (Norwich) Ltd.

Contents

(*Illustrations between pages 32 and 33*)

For Josephine

Acknowledgements

My first debt is to Nick Hammond. I am very grateful to him for giving me the opportunity to write this book. His generosity, care and inspiration as an editor have been unstinting. I would also like to express my warmest thanks to Robin Baird-Smith and Martin Rynja at Duckworth for their help and guidance. The University of Cambridge offered material assistance for a research trip to Paris. I am grateful to Nigel Wilkins for lending me his studio flat, where much of this book was written. Staff at the BIFI in Paris and the BFI library in London have offered much assistance; I am also very grateful to Tim Brown at the Ronald Grant Archive for his help in selecting stills. Many colleagues, students and friends have inspired and transformed my interest in French film; I would like to thank especially: David Cresswell, Gerard Duveen, Jill Forbes, David Forgacs, Susan Hayward, Andrew Lockett, Heidi Mau, Carmen Ana Pont, Keith Reader, Paul Julian Smith, Meryl Tyers, Virginia Vacy-Ash, Andrew Webber and students of Paper 125 (Contemporary European Cinema). I am particularly grateful to my mother, Jacqueline Wilson, for all the wonderful conversations about film we've shared since my childhood. Finally, I would like to dedicate this book, with love, to Josephine Lloyd.

Author's Note

Detailed bibliographical references have been kept to a minimum in this book. Lists of secondary reading appear at the end of each chapter. I would refer the reader in particular to the list of general studies of French cinema which follows the Preface: these works will be used throughout. I have also given references to reviews which have appeared in *Cahiers du cinéma*, *Monthly Film Bulletin* (for films appearing before 1990) and *Sight and Sound* (for films appearing after 1990). These excellent journals are often the source of the first engaged analyses of films and, in the case of recent films in particular, their discussions are invaluable. All the films which are discussed in detail have been released in the UK and US as well as France; in most cases video copies are widely available. I have kept technical language to a minimum, but a brief glossary of film terms appears at the end of the volume. Unless otherwise stated, translations of French quotations are my own.

Preface

'Je crois qu'au cinéma, il ne peut y avoir que des histoires d'amour' (I believe that in cinema, there can only be love stories). This will be a history of cinema as love story, and a study of the love of cinema. I begin with a quotation from the director Jean-Luc Godard since it is he perhaps who has contributed most to a rethinking of histories of (French) cinema over the last fifty years. His name, along with the names of other *nouvelle vague* directors, François Truffaut, Eric Rohmer, Agnès Varda, Claude Chabrol, Jacques Rivette, will return frequently in this study. For Godard, the *nouvelle vague* brought, above all, 'l'amour du cinéma'. This generation of young directors who came to prominence in the late 1950s have transformed French cinema with lasting effects. Yet this will not only be a study of their emergence and legacy. Rather it will explore the divergences of French cinema, and the multiple narrative strands of its own personal history.

French cinema since 1950 has proved immensely diverse, though constantly rich, influential and diverting. Certain trends can be seen to emerge, however. The first years of the period are marked by the aftermath of the Second World War and the new influence of American films in France after 1946. The 1950s were divided between the 'tradition de la qualité', which propagated popular literary adaptations, and a new-found, innovative love of cinema which found its focus in the journal *Cahiers du cinéma* founded in 1950, and in the work of a new generation of young critics and directors who formed the *nouvelle vague*. The films of the *nouvelle vague* dominated French cinema from the late 1950s through to 1968, although their influence and the continued creative output of directors such as Godard and Rohmer continue to be felt as late as the 1990s.

The 1970s can be seen to be marked by a new found politics of filmmaking, witnessed in particular in the work of feminist and more avant-garde filmmakers such as Varda and Duras. 1980 heralds the *cinéma du look* and a new attention to surface and image witnessed in the films of directors such Beineix, Besson and Carax. In the 1990s, by contrast, French cinema is dominated on the one hand by retrospective heritage films and on the other by films which explore social issues with gritty realism.

Other genres, such as comedy or the thriller, can be seen to form an important part of French filmmaking throughout all the decades under discussion. Equally, questions of history and testimony also run consistently through French filmmaking of the last fifty years in ways which ironically undermine a directly chronological approach to film of the period. Critics and historians have offered various accounts of film from this period, focusing on cinema as industry, as national product, and on cinematic genres. This study will partly be informed by these different approaches, but it will differ from most of the excellent overviews of French cinema which exist already. Many of the major issues and trends which have dominated French filmmaking of this period are discussed here, but I hope to offer more detailed and personal responses to a number of representative films from the period.

This is an introductory study, yet its aim is to provide a closer view of individual films and to encourage an awareness of the pleasures and complexities of spectatorship. While films from five decades are mentioned here, greater emphasis has been laid on the work of *nouvelle vague* directors, given the frequency with which they are studied in schools and universities. I have also included much discussion of films from the 1990s: general readers and viewers are probably most likely to have seen films recently released and little has been written on them so far. This also reflects a personal interest in contemporary film. The personal will be heavily at stake here, both in my approach to French film and in the argument I will develop. My aim is to suggest that the idea of a 'personal history' can be used usefully to explore and explain filmmaking in France in this period.

What does this idea of a personal history imply? The question of history itself, public and private, documentary or home movie, is central to French filmmaking of the past fifty years. Film as a photographic art-form appears ideally suited to offering true evidence and literal images of past events. Film can be seen as a faithful record. Yet ironically, as I will explore far further, post- war French cinema questions precisely this belief. Post-war French films repeatedly reveal the ways in which any history, and any cinematic representation of history, is both partial and personal. Recognising this fact need not change the political or historical import of film, but it does change our perspective on the medium and its status.

A rift can arguably be identified between films which deal with broad questions of public events and those which deal with the minutiae of their protagonists' private lives. Both strands in French filmmaking, in their different ways, question what it means to make a history or a life-story in images. French film seems to offer us indelible memory traces of past and present eras, icons and locations: it offers us the Hiroshima of Alain Resnais's *Hiroshima mon amour* (1959), the *cité* of Mathieu Kassovitz's *La Haine* (1995), yet also Bardot's rose and honey flesh in Godard's *Le Mépris* (1963) and Jean-Paul Belmondo's gorgeous gangster image in various films. French cinema reminds us that memory is close to fantasy, and that images can distort, idealise or impoverish the truth as much as preserve it.

Playing on the double meaning of the French *histoire*, story and history, I will explore life stories and love stories (looking at the autobiographical thread which runs through much modern French cinema), yet also public history (looking at films which represent trauma and response to historical events). Post-war French cinema is dominated above all, perhaps, by a concern with the medium itself, where films are shadowed by cinematic allusions, echoes of other films and references to the act of viewing and the very cinematic apparatus. Inevitably this study will be about the love of cinema found in films themselves, and about the love story with cinema which must inform a viewer's responses. This will ultimately be a personal history, which explores the place of spectatorship and personal response in a history of (post-war French) cinema.

Selected Reading

Guy Austin, *Contemporary French Cinema: An Introduction* (Manchester, 1996). A thoughtful introduction to French cinema since 1968; particularly interesting on the *cinéma du look*.

Jill Forbes, *The Cinema in France after the New Wave* (London, 1992). An excellent and engaging discussion of French cinema since 1968.

Susan Hayward and Ginette Vincendeau (eds.), *French Film: Texts and Contexts* (London, 1990). This volume offers a wide range of well-focused and specialist essays on a series of French films (1927-1985).

Susan Hayward, *French National Cinema* (London, 1993). An invaluable study of the French cinema industry, offering an economic perspective plus strong analyses of individual films.

Jean-Pierre Jeancolas, *Histoire du cinéma français* (Paris, 1995). In French. An important, brief introduction to the history of French cinema. A good starting point for studying this topic.

T. Jefferson Kline, *Screening the Text: Intertextuality in New Wave French Cinema* (Baltimore, 1992). A detailed study of seven films of the *nouvelle vague*. Sophisticated analyses which show a creative approach to film criticism and emphasise the importance of the literary text in *nouvelle vague* film.

James Monaco, *The New Wave* (New York, 1976). A good introduction to the *nouvelle vague*.

René Prédal, *Le Cinéma français depuis 1945* (Paris, 1991). In French. An invaluable resource and reference book for any studying French film of this period.

Claude-Marie Trémois, *Les Enfants de la liberté* (Paris, 1997). In French. A lively study of young French filmmakers of the 1990s.

Ginette Vincendeau, *The Companion to French Cinema* (London, 1996). An excellent and comprehensive companion guide.

1

Introduction: Cinema in the First Person

1. 'La Politique des auteurs'

When thinking about cinema as personal history in post-war France, one of the first issues to explore is 'la politique des auteurs', rather erroneously translated as *auteur* (author) theory. Regrettably, for many, as we shall see, this issue can be seen as a defining principle of French cinema since 1950. Indeed this issue continues to influence thinking about cinema far beyond France.

While notions of 'authorship' had already begun to enter film criticism, 'la politique des auteurs' is first named and proposed in coherent form in an article entitled 'Une certaine tendance du cinéma français' written by Truffaut when he was still a critic and not yet a filmmaker. This groundbreaking article was published in issue no. 31 (January 1954) of the journal *Cahiers du cinéma*, whose emergence goes hand in hand with that of what is now known as the *nouvelle vague*. Only 22 when he writes this article, Truffaut argues against the dominant forms of cinema in France in the 1950s. He holds up for characteristic disdain films of the 'tradition de la qualité', a tradition of filmmaking which marked French film production, in the immediate post-war years. The 'tradition de la qualité' depended on adaptations of prestigious, 'quality' literary works. The director was little more than a literary adaptor. Those criticised most volubly by Truffaut are Jean Aurenche and Pierre Bost, responsible for writing scripts for adaptations of Gide's *La Symphonie pastorale* (1946) and Colette's *Le Blé en herbe* (1953) amongst films drawn from many other literary works.

For Truffaut, the annexing of cinema as a form of literary illustration or enactment is a scandal. He celebrates instead a cult of the director whom he calls an 'homme de cinéma'. This notion implies several things to him. Firstly an 'homme de cinéma' will display technical expertise in the handling of images, over and above language. Yet he will also exercise creative control over the script and narrative of the film. As he adopts the title *auteur*, rebaptising his 'homme de cinéma', Truffaut adds that the *auteur* will often write his own dialogue and even make up the plots, the *histoires* of the films he will direct, becoming an author, effectively, in words and images.

Rethinking and Reprocessing the Past

Truffaut's attack on the 'tradition de la qualité' is sweeping and impassioned. It might be construed in Oedipal terms as the son's attack on the cinema of the father. Yet Truffaut is not fired merely by contempt for what has gone before. In some ways 'la politique des auteurs' heralds a break with the past and the emergence of a new school of directors (loosely the *nouvelle vague* and those around it). 'La politique des auteurs' is also concerned with rethinking and reprocessing the cinema of the past.

Truffaut is not merely intent on projecting himself as a newborn *auteur*, he is also driven by a desire to find different cinematic forefathers in his own personal history. To this end 'Une certaine tendance du cinéma français' isolates and names those directors who are already *auteurs* in Truffaut's terms: Jean Renoir, Robert Bresson, Jean Cocteau, Jacques Becker, Abel Gance, Max Ophuls, Jacques Tati, Roger Leenhardt . . .

The work of these directors frequently seeks to develop a personal style, or, in one way or another, to review a personal history. Although French cinema may be seen to change radically in the latter years of the 1950s, earlier directors offer a preview and inspiration of the personal aesthetic which manifests itself in later French cinema.

Their work is discussed in the earliest issues of *Cahiers du cinéma*,

which was first published in April 1951 (which date partly affords the starting date for this book). The very first issue contains a review of Robert Bresson's *Journal d'un curé de campagne* (1950), a film which is treated to more protracted analysis in issue 3, by André Bazin, editor of the *Cahiers du cinéma* and mentor to the young critics who instigated the *nouvelle vague*. Although it is a literary adaptation (of Georges Bernanos's novel), *Le Journal d'un curé de campagne* could not be further from the 'tradition de la qualité'. Bresson develops a highly individual style, typified by stark images, silences and absences, ideally suited to the recurrent concern with spirituality in his cinema from the 1940s on. In *Le Journal d'un curé de campagne*, Bresson also explores the possibility of a diary form in cinema, changing both the form and content of French film.

Other Influences

It is important not to establish too complete a break between *nouvelle vague* cinema and earlier French filmmaking. Another film of the 1950s which is treated lavishly by *Cahiers du cinéma* is René Clément's *Les Jeux interdits* (1952). While this again is a literary adaptation (from a novel by François Boyer) by Aurenche and Bost, the film nevertheless bears certain resemblances to later cinematic attempts to represent trauma through personal history. *Les Jeux interdits* explores the fate of a tiny war orphan, Paulette (Brigitte Fossey). She has seen her parents gunned down as the roads out of Paris are bombed to halt a mass exodus in June 1940. Paulette, still clutching the little carcass of her pet dog, is rescued by a child, Michel, and sheltered with his family. The adult protagonists are presented in a caricatural and stereotyped manner; the children carry the emotional weight of the film which becomes a drama about faulty mourning and childhood love. The mass events which determine the narrative are represented with new force through the filter of the children's friendship. Within the confines of the 'tradition de la qualité', it is still possible to develop a personal history in an affecting new idiom. Films which offer such a

perspective find favour in the groundbreaking new journal *Cahiers du cinéma* as it develops a new cinematic aesthetic, which is previewed in Truffaut's article.

In his article, Truffaut also tries to define a new relation between French cinema and Hollywood. France was flooded with Hollywood films in the immediate post-war years. American imports had been banned under the Occupation; this ban was lifted with the Blum-Byrnes agreement of 1946. 'La politique des auteurs', as put forward by Truffaut, is a response to youthful cinephile film-viewing in the late 1940s. Truffaut and other directors associated with the *nouvelle vague* such as Rohmer and Chabrol, responded to the films of Alfred Hitchcock and others, finding in them, despite studio and genre constraints, the filter of an individual's vision. Importantly 'la politique des auteurs' does not limit its concept of an *auteur* to directors of art cinema (as happens frequently later) but, through its engagement with Hollywood, embraces popular cinema as well, valuing its potential to appeal to a wide audience yet tell – however obliquely – a personal history.

'La Politique des auteurs' as Politics and Policy

Thinking about Truffaut's 'politique des auteurs', it may be helpful to remember the double meaning of the French *politique*: both policy and politics. All too frequently 'la politique des auteurs' has been applied as policy but neglected (or reviled) as politics. This is a contentious issue and one which leads us to the manifold reservations which critics and historians of cinema, then and now, have expressed about 'la politique des auteurs'.

Perhaps the most important criticism that has been levelled against 'la politique des auteurs' is that it is politically reactionary; an attempt to remove film from the realm of social and political concern. This criticism is justified, in part, by the fact that 'la politique', as conceived by Truffaut and taken up by others, is expressly formalist. It values a film's form over its content, looking at the ways in which a director works with the cinematic medium itself,

exploring the aesthetic and technical aspects of a particular film. The political message, historical or social import of the subject matter of a particular film is thus, supposedly, seen to be of little concern. To make matters worse, *Cahiers du cinéma*, the periodical in which Truffaut's article appeared, has been seen to move between apoliticism and a right-wing position (in contradistinction to its rival publication, the politically committed, leftist *Positif*).

Ironically, further criticisms of 'la politique des auteurs', now as policy rather than politics, are voiced by André Bazin. In 1957 Bazin put forward his own view of 'la politique des auteurs' in *Cahiers du cinéma*, expressing a series of qualms. The main focus of Bazin's critique is the danger of the cult of the *auteur* and its risks for film criticism. He suggests that the subject matter is reduced to zero in the cult of the author.

Furthermore, Bazin surmises that 'la politique des auteurs' depends on a type of heroic myth whereby the personal factor, once isolated in a particular director's work, can be seen to continue and even to progress from one film to the next. He is dubious about this notion of progression and gradual assumption of a position of genius and integrity. One only has to think of disappointing late films by particular directors to agree with him.

Speaking in the First Person

Importantly, Bazin doesn't seek to undermine the notion of the *auteur* as such, but to advise against the over-valuation of any film just because it is 'by' a particular *auteur*. He stresses, in fact, that cinema, more than the other arts, in its late-coming status (barely sixty years old as he was writing) may profit from a cult of creativity and individual expression. This arguably allows cinema to be taken more seriously, and not to be dismissed as mere entertainment.

Again this is a tricky issue, for two main reasons. Firstly, any cult of the director alone, even the move to say that a film is 'by' Godard or Renoir or whoever, overlooks cinema as an industry and filmmaking as necessarily collective enterprise dependent on the

individual (and collective) talents of the cinematographer, the set designer, the actors, the editor, and others as well as those of the director. Secondly, if we are willing to ignore the collectivity of cinema as enterprise, valuation of the director as *auteur* still sits uncomfortably in the context of literary-critical, and particularly post-structuralist (*) questioning of the function, and the death, of the author.

The notion of the death of the author, put forward by the critic Roland Barthes, has been used to argue that we should consider a text (or a film) in its own right, divorced from the influence or interpretation offered by its author. This way of reading has proved very important in opening up interpretations and freeing up possibilities for the reader of a text (or the viewer of a film). Barthes himself has said that the death of the author allows the birth of the reader. While gaining greater currency, the notion has gradually been distanced (as appropriate perhaps) from what Barthes actually wrote, leading to the loss of any interest in the author. For Barthes, the authority and the 'paternity' of the author should be stripped away, together with authenticating reference to biographical details in interpreting particular texts. Nevertheless, Barthes acknowledges that a fantasy of the author may still preoccupy us as we read, even if we acknowledge this is a product of our own imagination. It is with this projection of a figure of the *auteur* (or filmmaker) that I am more concerned here.

Bazin argues in his article on 'la politique des auteurs' that, to a certain extent at least, the *auteur* is always his own subject matter. He goes on to remind us of a definition of the *auteur* given by the director Jacques Rivette. For Rivette, an *auteur* is someone who speaks in the first person. Bazin suggests this is a good definition, which should be adopted. What I am concerned with here is looking at the possibility of still adopting this definition while

* Post-structuralism is a school of thought which emerged in France in the 1960s. Post-structuralist theorists emphasize the instability of meanings and of intellectual categories; the search for a free play of meanings leads to the questioning and devaluation of the authority of authors and directors.

remaining sceptical about 'la politique des auteurs' for the very reasons outlined above.

Personal History

For better or for worse, the notion of the *auteur* refuses to die definitively in film criticism. The term is used with due caution and critical distance in journals such as *Sight and Sound* and *Screen*, though more freely in their French counterparts. Writers of monographs (myself included) mention the risks of auteurism – i.e. placing too much emphasis on the director as source of meaning – even when adopting such an approach. It will remain an issue, even if rejected and outmoded, for anyone who studies cinema.

Can the concept be redeployed? This is where the concept of 'personal history' comes to the fore. The personal can be seen as a dominant concept in French cinema of the last fifty years. This is directly linked to 'la politique des auteurs' through the notion of cinema in the first person. The first person may be seen as a defining principle or perspective, yet also as a constraint, and this is important. The concept of 'personal history' may be used to bring together form and content (rather than separate the two as in the classic critique of 'la politique des auteurs').

The director, and the other artists with whom he works, may seek to change the forms of representation and images produced, not for the sake of innovation alone, but in respect of the creative possibilities of a particular *histoire*. The director's perspective, the personal 'take' on the story, be it autobiographical or not, becomes of prime interest. Through both form and content, a director may seek to unravel or deconstruct an identity; be it artistic or personal, his own or a protagonist's.

Importantly, cinema is a means of demonstrating how identity is formed and construed artificially. Here I am introducing ideas about identity that are drawn from Freud and that have been taken up more recently with a political slant by the feminist theorists Judith Butler and Diana Fuss amongst others. For Freud, we all become a 'self' through identifying with images and with other

people. We take on their traits, we internalise them, consciously or unconsciously, in an attempt to construct an identity for ourselves.

Film can offer a magnified representation of this very process where, for example, we see the louche, yet immature gangster Michel in *A bout de souffle* look at the image and imitate the gestures of his cinematic alter ego, Humphrey Bogart. Cinema produces a stock of images which individuals take on innocently: girls dressing like Béatrice Dalle in *37°2 le matin* (1986) or Uma Thurman in *Pulp Fiction* (1994), or disastrously with two teenagers tried in France in 1998 for the murder of one of their classmates claiming the inspiration of *Natural Born Killers* (1994).

Cinema may provide us with identity images, yet it can also remind us that identities are unstable, change through time, location and encounters, have many facets and are inherently unknowable. This applies to the identities of those characters who are the subjects of the personal histories which cinema treats. Yet it must also, surely, apply to the identities of the directors, or *auteurs*, who make these films.

Spectatorship and 'La Politique des auteurs'

Can 'la politique des auteurs' be stretched to allow the fact that an auteur's identity is constantly in flux, determined by both internal and external pressure and influence, and ultimately unknowable however carefully a critic views and reviews, charts and codifies individual films and the development between them? What we must be left with is a constant play between similarity and difference where a film 'by' Godard or Truffaut, for example, will resemble and differ from his others in variable measures. This may sound like a truism, yet it is a source of *auteur* criticism which is not shy of the personal, yet shows the personal and the individual to be a constant fiction, where identity will always be open to change and transformation. And this flexibility, this unknowability, will also allow or necessitate a personal factor in interpretation as the viewer engages with his or her fantasy of the personal history pro-

jected. Spectatorship, seemingly ignored in 'la politique des auteurs', thus comes back into play.

If the personal history remains inherently unknowable, unknowability may be seen also as a determining mark of films which attempt to explore public history and trauma. The personal may be uncertain, vacillating and unreliable, it remains nevertheless perhaps the only ethical means by which directors have sought to contend with the historical events which have determined the last fifty years of the twentieth century, and which have necessarily been rethought and reprocessed in cinematic representations.

In this way too, the personal need not be the mark of the politically reactionary, individual, *intimiste* approach. It is a privileged means, however limited, to offer some hope of a purchase on history and trauma in representation. This point might be extended to apply also to the representation of minority identities, of prejudice and exclusion where personal experience becomes an index of authenticity. In this way, then, through a deconstruction of identity and a validation of the individual perspective in the absence of any possible collective response, it is possible to re-politicise the notion of a 'personal history', to bring identity politics and the ethics of representation into 'la politique des auteurs'. At this point it is more than time to begin looking at some films.

2. The Birth of the *Nouvelle vague*

The first film that I want to look at as a 'personal history' is Truffaut's *Les 400 coups* (1959). This was his first feature film, following several shorts, notably *Les Mistons* (1957). Together with Godard's *A bout de souffle*, it is one of the first popular successes of the emerging *nouvelle vague*. It is also the first appearance of Truffaut's cinematic alter ego, Antoine Doinel. Truffaut continued to make more than twenty other films before his death in 1984, including the *film noir Tirez sur le pianiste* (1960), the triangular love story *Jules et Jim* (1961), *La Nuit américaine* (1973), an important film about film production and cinema itself, and *Le Dernier métro* (1980), a costume drama set in the Occupation, bringing together

the actors Catherine Deneuve and Gérard Depardieu, and proving Truffaut's most popular film at the box office in France.

In this diversity of filmmaking, it is first of all the biographical thread that I want to discuss, a thread Truffaut himself drew out in four films which followed *Les 400 coups*: *Antoine et Colette* (1962), *Baisers volés* (1968), *Domicile conjugal* (1970) and *L'Amour en fuite* (1979). When Truffaut creates his protagonist Antoine Doinel, played by Jean-Pierre Léaud, he is not content to leave him frozen at the end of *Les 400 coups*, but waits for the actor to grow up (and to assume an uncanny resemblance to Truffaut himself) before continuing his life history.

A First Person Subject

Les 400 coups is treated as a semi-autobiographical film. It is certainly, with the exception of *La Nuit américaine* in which Truffaut himself appears and which by virtue of its subject matter is a rather different case, the film which comes closest to a narrative of the events of Truffaut's own life: here his early adolescence. Details of the events of Truffaut's life can now be found in the biography of *François Truffaut* by Antoine de Baecque and Serge Toubiana. Suffice it to say that Truffaut's father did indeed hand his son over to the police, as does Antoine's in *Les 400 coups*. And the young Truffaut was, like Antoine, then sent to a detention centre. But *Les 400 coups* contains much more than confessional filmmaking, or an attempt to fix memories of injustice or insurrection in celluloid.

Les 400 coups is a film which above all questions what it is to create a personal history in film. Antoine Doinel as protagonist becomes a means for Truffaut to test the potential of cinema to create a first person subject, and to make of his life a case history in images. In the first Antoine Doinel film, Truffaut traces a fourteen year old's experiences, in the classroom, with his parents, with his close friend René, and on the streets of Paris, on the several occasions he runs away from home. The tone of the film is alternately light and raw. It treats misreading and betrayal towards its conclusion, as Antoine becomes embroiled in an attempt to

return a typewriter he has stolen from his father's office. This leads to his detention in the COM (Centre d'observation de mineurs délinquents) from which he escapes at the film's close.

On one level Antoine's character is explored with piercing vision and psychological realism. He is shown to be both independent and immature, deceptive, playful, yet also literary and idealistic. We see him exultantly finish Balzac's *La Recherche de l'absolu*, paste a portrait of Balzac on his wall and light a candle in his small literary shrine (which later burns down). Truffaut seems to signal the literary debts he incurs in creating this juvenile hero. Antoine Doinel seems consciously a copy of Stendhal's Julien Sorel (*Le Rouge et le noir*) or Balzac's Lucien de Rubempré (*Illusions perdues*). Finding literary precedents like this, showing a cult of the author (Balzac), in his film, Truffaut seems consciously to seek this elevated status as *auteur* himself, or more excusably, to draw attention to the links between literature and cinema which may be generative and productive. Remembering his critique of 'la tradition de la qualité', we see that for Truffaut film need not be a pale imitation of literature, but literature's progeny and revitalisation.

Film as the rebellious offspring of the literary text seems an apt notion given the drama of paternity and illegitimacy which underlies *Les 400 coups*. The relation between father and son was already of much concern in *Le Rouge et le noir* and *Illusions perdues*. Julien Sorel looks with contempt at his father and wishes to be illegitimate. Lucien de Rubempré finds a false father (and platonic lover) in the demonic Vautrin who tries to guide his fate. Antoine Doinel, as we find out very gradually in the film, is himself illegitimate. His mother married his 'father' when he was a small baby. He was sent out to a nurse, brought up by his grandmother until the age of eight, and only then came to live with his parents in the cramped Montmartre apartment we see in all its disaffected domesticity. The only moments of family happiness in the film occur when Mme Doinel suggests a trip to the cinema after the burning of Balzac's shrine fills the apartment with smoke.

Spectatorship and Self-Reflexivity

Cinema becomes in *Les 400 coups* a space of safety, refuge and false family values. Notably the film is dedicated to the memory of André Bazin, who became something of a false father to Truffaut, offering him a home and a job as projectionist after his release from the detention centre. Cinema as much as, or more than literature, is Antoine's refuge in *Les 400 coups* as, in true cinephile fashion, Antoine and René go to the cinema when they play truant, stealing a film-still on the way home. Cinema is one of Truffaut's subjects in *Les 400 coups*. It is also crucially important to the way in which he re-conceives a life history, and the destiny of his protagonist Antoine.

Les 400 coups tells a life story in pieces. The events of Antoine's life which I have mentioned above are never narrated directly as a single story. Gradually the film viewer gathers evidence, and puts a fuller picture together. Truffaut multiplies the perspectives from which we view Antoine. In this way he makes a double statement about both identity and cinema. On the one hand, identity is never fixed and always changing. On the other, cinema as a mobile and temporal art form becomes the perfect medium to explore different, divergent images of a self. Thus Truffaut shows the complexity of a personal history, and shows off his virtuosity as director. *Les 400 coups* is also a personal history of all that cinema can do, and how the medium is re-invented in the *nouvelle vague*.

I have mentioned that Antoine is detained in a 'Centre d'*observation* des mineurs délinquents' (my emphasis). And *Les 400 coups*, while always attempting to portray the liberation of the protagonist, ironically becomes its own observation centre. As viewers we *observe* Antoine (or the image of Jean-Pierre Léaud): his image is continually fixed. *Les 400 coups* offers a commentary on this process where series of scenes seem much more important in terms of what they reveal about identity and imaging, than in terms of their position within the overall cinematic narrative.

Take for example, the scene where Antoine first comes home from school. The apartment is empty and he goes to sit for a

moment in his parents' bedroom, in front of his mother's dressing table mirror. We see his image reflected three times in the folding panels and also in the vanity mirror below. In a classic image of reflection which recurs many times in cinema (for example, the mirror scenes in *Hiroshima mon amour* and *A bout de souffle*), Truffaut shows an image of the self refracted, the individual made into a series of images. This self-reflexivity, or internal comment on the properties of cinema as medium of reflection, is one of the distinctive aspects of the *nouvelle vague*.

Still Images and Speed

Another aspect of the *nouvelle vague* is a concern with speed and acceleration. This is partly a means of drawing attention to film as motion picture, to release its energy and show its vitality (take the chase over the bridge in *Jules et Jim*, the car journey that begins *A bout de souffle*).

In *Les 400 coups* a virtuoso scene of speed and vitality takes place in the rotor at the fairground. We watch Antoine enter, find his place against the stationary cylinder and then gradually become deformed, even agonised by speed as the cylinder accelerates and the floor drops away. The ambiguous emotions of the scene, between fear and ecstasy, seem apt to the film. So does its dual perspective. The film shifts between images of Antoine as stationary focus of the camera's view (so he seems pinned, squirming against a canvas for us to observe) and images directly from his point of view of the audience in the viewing gallery (amongst whom is his friend René) who watch his adventure. Ironically the audience appear to move, they are viewed so fast, like the grotesque figures of a zoetrope trip. Given that the zoetrope was itself an embryonic form of cinema (where a series of still, but gradually changed images sped very fast past a shutter to create an impression of motion), Truffaut appears to remind us of the very raw materials of his medium. If the *nouvelle vague* can be seen as a re-birth of cinema, directors can be seen to go back to question the very origins of the medium.

Cinema depends on the creation of an illusion of movement out of still images: in fact, on still frames or photographs which are projected at a rate of twenty four frames per second. As Godard reminds us: 'le cinéma c'est vingt-quatre fois la vérité par seconde', cinema is the truth twenty-four times a second.

Truffaut explores this relation between still and moving images further. If we have seen Antoine's image refracted in the multiple mirrors and fixed in motion in the rotor, we also see him fixed photographically, once literally, and once, more poetically, in the last frame of the film. The literal image of Antoine is taken at the detention centre where he is lined up in profile and his identity picture is taken. The film seems to show the arbitrariness and brutality of this art. The living, moving boy, played by Léaud, with whom the camera seems particularly enamoured, is suddenly a photographic caricature. His image is fixed for his file.

The image takes on a pathological status: it is reminiscent of the images of criminals and the insane taken by Charcot and others which (along with Eadward Muybridge's motion studies of animals) influenced the development of cinema. Truffaut seems to show ironically the fixity of the photographic image, its inability to capture a moving identity.

Viewpoints

Yet this scepticism about the medium seems overturned at the end of the film. By this time we have gradually come closer to Antoine. This is achieved notably in the sequences where he is interviewed by the detention centre psychiatrist. At points earlier in the film, although we have shared Antoine's direct view of events (in the rotor, for example), we have also seen him from a distance. Again exploiting the potential of the medium, Truffaut at times gives us a bird's eye view of his protagonist, reducing him to a shadow or moving shape in an exercise exploring perspective and viewpoint.

But now, as we are about to leave him, we come close to Antoine. As the psychiatrist asks inane questions, we watch Antoine, always from the clinician's perspective. It seems as if

Léaud talks directly to camera, as the film apes documentary. The interview, with its illusion of documentary objectivity in form and content, becomes a further way to approach the representation of a personal history.

The camera is now content to follow Antoine, making the trajectory of his identity and his narrative the very path our viewpoint will take. Antoine makes his escape from the detention centre, and is at first followed by one of the guards. He gives him the slip, but remains still the object of the camera's visual attention, as for long moments we watch him running through the countryside, and finally to the shore, to the sea which he is seeing here for the first time, and into one of the most famous scenes in French cinema of the past fifty years. Truffaut follows his protagonist onto the shore until, with the waves behind him he turns as if to confront the camera and is caught suddenly, his face entirely open and expectant, in a freeze-frame.

This is the innovation of the end of the film. Yet its point of emotional intensity is also perhaps its acknowledgement of failure. Film still gives a fixed image of Antoine. Truffaut seems to open this as a question at the end. He offers an admission of artifice, effecting an abrupt rupture of the identification with Antoine which we have doubtless experienced. The personal history freezes, questioning its own possibility, and the medium in which it is produced.

This image has been reproduced in other films which seek a point of contact with the *nouvelle vague* and the newly imagined personal history Truffaut projects (as we shall see in Chapter 2). In a film of vibrancy and elated visual possibility, Truffaut nevertheless already envisages limits and impossibilities in representation. These seem reached in the pleasurable yet less visually innovative parts of Antoine Doinel's history in Truffaut's later films.

3. The Death of the *Nouvelle vague*

Leaving Antoine, it remains in this chapter to consider briefly the currency or legacy of the *nouvelle vague* in French cinema today. To

do this I would like to turn to a much more recent film, Olivier
Assayas's *Irma Vep* (1996). The immediate point of contact between
Truffaut's Antoine Doinel cycle and *Irma Vep* is the reappearance
of the actor Jean-Pierre Léaud. Note that an alternative classifica-
tion of films, avoiding dependence on the *auteur* or director as
guarantor of value and identity, depends on the presence of an
actor.

This need not just take the form of cult worship (where
someone will see every film starring Depardieu). It is also recog-
nition that actors bring with them certain meanings and qualities
which may be sought by a particular director. This can be wit-
nessed in the meaning and image carried from film to film by
actors who became real icons of the *nouvelle vague*: Jean-Paul
Belmondo or Jeanne Moreau for example. Consider the effect
created in a more recent film by Josiane Balasko in her choice of
Victoria Abril fresh from Almodóvar's Spanish cinema to play Loli
in *Gazon maudit*.

The casting of Léaud in *Irma Vep* is rich with significance.
Aptly he plays a film director, indeed the director of the film
within the film which is the subject of *Irma Vep*. The identifica-
tion between Léaud and Truffaut seems complete where Léaud
now plays a director of Truffaut's generation, indeed one of his
very type.

What Assayas achieves in *Irma Vep* is a questioning of the death
of the *nouvelle vague* as he shows Léaud acting a director out of
touch with the current reality of the film industry. This is a res-
onant issue in current French filmmaking where the values of
this former generation of directors are brought into question.

Yet this repudiation is simultaneous with a metamorphosis of
the values and possibilities of *auteur* cinema in the matter of
Assayas's own filmmaking. Like Truffaut, Assayas himself worked as
critic at *Cahiers du cinéma* before beginning to make films.
Ironically he is one of France's newest generation of *auteurs* pre-
cisely where he represents the solipsism (absolute egotism),
demise and insanity of *nouvelle vague* cinema in *Irma Vep*.

Remaking the Past

Irma Vep is deeply and critically embedded in the tradition of French cinema, stretching back beyond the last fifty years. It takes as its subject a director's attempt to remake Louis Feuillade's serial *Les Vampires* (1915-1916). *Les Vampires* spotlighted the notorious Irma Vep (played by Musidora, a music-hall artist). Irma Vep (an anagram of vampire) brought with her gender disarray and general criminality in her clinging black catsuits and anarchic acts. She will be reviewed by Assayas and his fictional director.

The whole question of remakes is vexed in contemporary cinema. It often brings with it questions about national cinema and its export value, referring most frequently to American remakes of European films (for example, *Three Men and a Baby*, 1987, a remake of Coline Serreau's *Trois hommes et un couffin*, 1985). Assayas brings a different sense to the remake, however, making the possibilities and necessity of reprocessing the art of the past his subject. He gives the question a post-modernist dimension. Theories of post-modernism can be seen to value the copy over the original, and to reveal that art of this cultural and historical period (since the 1960s) is layered with allusions, self-reflexive and surface without depth. Assayas leads us to enjoy the layers of allusion in *Irma Vep*, which is a very calculated work: a cinephile work creating intellectual as well as visual pleasure for the viewer. He translates early French cinema and the *nouvelle vague* into a sharp new idiom. He achieves this first through his choice of actress to play Irma Vep.

This is a point of contention both within the film and outside. He chooses Maggie Cheung, the exquisite star of many Hong Kong action movies. Visually she is a perfect high tech, body beautiful image of Musidora: lithe in black latex (a source of comic speculation in the film itself), she captures and renews Irma Vep's allure. Yet being Chinese (though Cheung herself was brought up in Kent), her image clashes with the integral Frenchness that the icon Irma Vep represents.

This seems in keeping with the use, indeed fetishisation, of for-

eign actors in the *nouvelle vague.* Jean Seberg in *A bout de souffle* (1959), Anna Karina in *Pierrot le fou* (1965), Eiji Okada in *Hiroshima mon amour* (1959) or Hiroko Berghauer in *Domicile conjugal* (1970). Cheung's face and its make-up seem particularly reminiscent of the image of Anna Karina in Godard's *Vivre sa vie* (1962), which is itself compared to the image of Falconetti, the actress who played the title role in Dreyer's *La Passion de Jeanne d'Arc* (1928).

Yet recalling the *nouvelle vague,* Assayas also renews it in his internationalism and his focus on the film industry itself as international. This is witnessed particularly in the fact that much English is spoken in *Irma Vep,* for verisimilitude by Maggie Cheung who plays herself, but also as a comment on the way English has become the lingua franca of the movie industry.

That Maggie Cheung plays herself is important and crucial to the way the film works to focus on the relation between reality and its cinematic representation. Assayas closely questions the role and involvement of an actor in the part she or he plays.

Reality and Representation

Les Vampires as made by Feuillade is a fantasy piece. In one way at least *Irma Vep* as made by Assayas is true to this aesthetic. There is one sequence in the film which is mystifying and unplaceable. (It is analysed frame by frame in *Cahiers du cinéma.*) At night in a large hotel, still dressed in her latex, Maggie goes wandering the corridors. She opens a door to a room where she finds a naked woman on the telephone. (This woman is played by Arsinée Khanjian, icon and muse of Toronto-based director Atom Egoyan.) Maggie proceeds to steal a handful of jewels, disappears down a fire escape and across the roof. She seems to have taken on the criminal identity of the part she plays in the film within the film: Assayas shows a fluid division between acting and the performance of one's identity. Yet it is never confirmed whether this scene is supposed to be literal, pure fantasy, dream sequence or wish-fulfilment. In this ambiguity lies its interest.

Much of the rest of the film disconcerts in different ways, and in ways deliberately built into the process of filming. In interview Maggie Cheung talks about the filming of a particular scene where she is at dinner with members of the crew after shooting. She is talking in the kitchen with another woman who suddenly reveals that their mutual friend, the film's wardrobe mistress, is very attracted to Maggie. Cheung's amazed response seems entirely genuine as we watch the film. It was, she tells us, since she had been told to improvise her replies in the scene and had not been prepared for what was coming.

The use of improvisation in French cinema is not unique to Assayas, but is used by various directors to give an air of spontaneity and chance to a particular scene (the device has been used particularly effectively by Eric Rohmer). In *Irma Vep*, the scene closes the distance between the part Cheung is playing, and the actress herself. It works also to open out the casualness and contemporaneity of Assayas's approach. *Irma Vep* takes us into different territory from *nouvelle vague* films. Assayas explores different areas of Paris: the dinner party is in an attic apartment in Belleville, the desirous wardrobe mistress takes Maggie out to a rave in a warehouse in the *banlieue*. The film is relaxed too about sexuality; the lesbian sub-plot is no big issue.

Irma Vep succeeds where its fictional director's remake of *Les Vampires* fails. The director, played by Léaud, is in despair when he sees the rushes after the first day's shooting. The film ends with his nervous collapse, with another director taking over the project and Maggie departing for the US. Assayas seems to suggest that French cinema should look forwards rather than backwards, that it must look out rather than in: navel-gazing is one of the chief accusations against the remnants of the *nouvelle vague*.

Yet perhaps we cannot ignore the fact that *Irma Vep* locates Assayas himself in and against the history of French cinema. He makes it his personal history, by renewing as well as reviling the forms of *auteur* cinema. The phantom of the *auteur* still haunts French cinema, even if he is brought back only in a film about a film about the living dead.

Selected Reading

Antoine de Baecque and Serge Toubiana, *François Truffaut* (Paris, 1996). A full and readable biography of Truffaut.

John Caughie, *Theories of Authorship* (London, 1981). A clear, authoritative introduction to *auteur* theory which includes extracts from some of the most important writings on the topic.

Diana Holmes and Robert Ingram, *François Truffaut* (Manchester, 1998). A thoughtful and concise introduction to Truffaut.

Keith Reader, 'The Sacrament of Writing: Robert Bresson's *Le Journal d'un curé de* campagne' in Susan Hayward and Ginette Vincendeau (eds.), *French Film: Texts and Contexts* (London, 1990), pp. 137-146. This is an engaging and revelatory study of Bresson.

François Truffaut, *Le Plaisir des yeux* (Paris, 1987). In French. This volume of Truffaut's writings on film contains his important article, 'Une Certaine tendance du cinéma français'.

Films

Les 400 coups: Cahiers du cinéma, no.95 (May 1959), pp. 37-39; *Cahiers du cinéma*, no. 96 (June 1959), pp. 41-43; *Cahiers du cinéma*, no. 97 (July 1959), pp. 52-55; *Monthly Film Bulletin*, no. 315 (April 1960), p. 48.

Irma Vep: Cahiers du cinéma, no. 507 (November 1996), pp. 37-41, 45-47; *Sight and Sound*, vol. 7, no. 3 (March 1997), pp. 24-26, 51-52.

Antoine Doinel, now an adult, in *Baisers volés* (The Ronald Grant Archive).

Antoine Doinel (Jean-Pierre Léaud) at school in *Les 400 coups* (The Ronald Grant Archive).

Unsafe sex in *Les Nuits fauves* (The Ronald Grant Archive).

Betty (Beatrice Dalle) and Zorg (Jean-Hugues Anglade) in *37°2 le matin* (Betty Blue) (The Ronald Grant Archive).

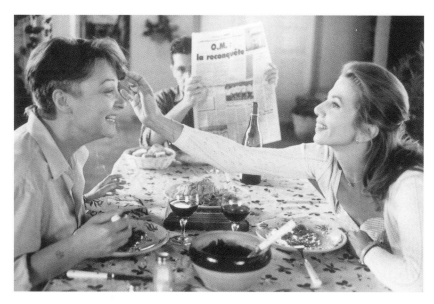

Victoria Abril as object of desire in *Gazon Maudit* (The Ronald Grant Archive).

Sexual difference in *A bout de souffle* (The Ronald Grant Archive).

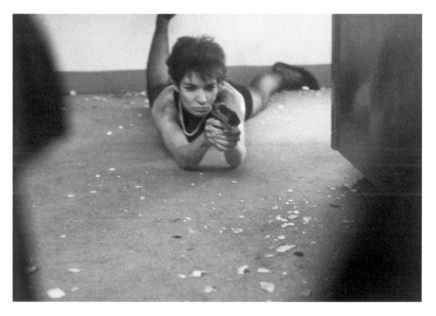

A girl and a gun: Anne Parillaud in *Nikita* (The Ronald Grant Archive).

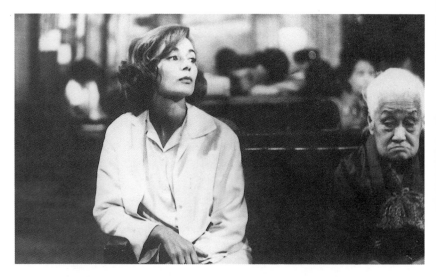

Trauma and isolation in *Hiroshima mon amour* (The Ronald Grant Archive).

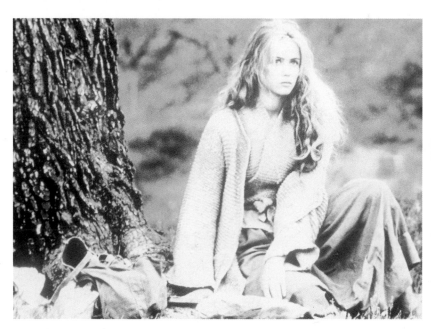

Emmanuelle Beart embodies a myth of femininity in *Manon des sources* (The Ronald Grant Archive).

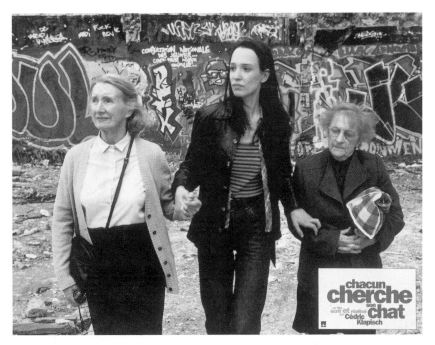

Women in the city in *Chacun cherche son chat* (The Ronald Grant Archive).

Female friendship and retro chic in *Mina Tannenbaum* (The Ronald Grant Archive).

Godard's fascination with women: Anna Karina in *Une Femme est une femme* (The Ronald Grant Archive).

2

Film and (Auto)Biography

T. Jefferson Kline writes in *Screening the Text* (1992): 'Film is always autobiographical in the sense that, for filmmaker and spectator alike, the view (whether through viewfinder or from images perceived in darkness) is a voyeuristic one' (p. 1). He suggests that film takes us to a place and puts us in a position where we can review and remember the images or first scenes which have indelibly marked our life and identity. Film is autobiographical not just because it can represent life histories, but also because it works in a manner surprisingly like memory and dream. Our own life histories, made up of images we view in our mind's eye, become a type of personal cinema. Marguerite Duras draws attention to this in her novel *Le Ravissement de Lol V. Stein*. Lol is a character caught in a web of her own fantasy and memory; this Duras describes as 'le cinéma de Lol V. Stein'. Tellingly Duras's own films, for example the languorous *India Song* (1975), resemble mental rather than literal images, and have all the circularity, obsessive repetitions and illogicality of thought patterns or memories.

Film is autobiographical, then, in the way it reminds us about how we remember and what we remember. The matter of images is comparable in film and in memory. In the (auto)biographical films I want to introduce in this chapter, image, vision, memory and history will be seen to be always questioned and never assumed. As we saw in the case of *Les 400 coups*, although resemblances may exist between a director's life and the life history he or she represents, little is gained by merely pointing this out. The directors I will look at here work, like Truffaut but variously too, rather to explore how film can present a life history, and how personal histories can always already be seen to be cinematic. Personal

histories can be seen metaphorically as so many 'films' that we project for ourselves in our memory or imagination. Home movies, which are often a source of memories, only literalise this analogy further. The life histories in the films I will look at are seen to be irrevocably caught up with questions of public history and politics. The other issues which inflect and enforce the re-invention of a life history and its visual forms are (unsurprisingly) sexuality and death.

1. Tous les garçons et les filles de leur âge

The first (auto)biographical film I want to explore is André Téchiné's *Les Roseaux sauvages* (1994). The film formed one of a series of nine films which were commissioned for television by Chantal Poupaud on behalf of IMA productions and the television station La Sept/Arte. Three of these – *Les Roseaux sauvages*, Olivier Assayas's *L'Eau froide* and Cédric Kahn's *Trop de bonheur* – were also shown at the Cannes film festival in 1994. The venture as a whole signalled a new accord in film and television production. The series was entitled *Tous les garçons et les filles de leur âge* (all the boys and girls of their age) and the director's remit was to make a fiction of the period of their adolescence (allowing the series to range from the 1960s to the 1980s). The title of the series has sociological overtones, as René Prédal points out, yet he reminds us too that it also refers to a song by Françoise Hardy. Poupaud suggested: 'Adolescence, musique, mémoire' as a subtitle for the series as a whole and this sums up well the way that youth, popular culture and yet also reminiscence, reflection and a backwards glance will animate the films.

In the remit, these films are called to exist as personal histories, not as direct autobiographical works necessarily, but as memory pieces, as traces of an era and the existence of an individual in that era. They mark a new departure in French filmmaking, signalling a new realism (felt in the most recent domestic successes at the French box office: for example Eric Zonka's *La Vie rêvée des anges*, 1998) and the emergence of new *auteurs*. This is not strictly the

case of Téchiné himself, who concerns us immediately, since he has been making films since 1969! Ginette Vincendeau (1996) describes Téchiné as 'one of the most important post-New Wave French directors'. In the last decade his films have been more widely distributed in the art cinema circuits in the UK and US, and although slow to achieve more than a dedicated following abroad, his films are now more widely viewed and studied in universities (and for very good reason).

Téchiné's filmmaking is typified by an intimate, non-judgmental focus on his protagonists, their inner and outer dramas, their locations and their histories. He charts small changes, in a visual style which is understated and immeasurably subtle. This produces particularly heartfelt effects when set against subject matter which can be far more provocative. Téchiné avoids sensationalism at all costs and thus offers a new image of sexual and emotional transgression (notably representing adolescent desires and even incestuous relations). This is viewed, for example, in his 1991 film *J'embrasse pas* which charts the progress of a young boy who leaves his home in the countryside to go to Paris. After little success embarking on a career as an actor he sleeps with an older woman (played with moving vulnerability by Hélène Vincent) for money and gradually takes on a role as a male prostitute. Téchiné explores sexuality with delicacy, never retaining rigid boundaries between homosexual and heterosexual. This is the case too in *Les Roseaux sauvages*. In some ways *J'embrasse pas* works effectively as an updated comment on *Les 400 coups*: the protagonist is a little older, a little more desperate than Antoine Doinel. Yet he arrives in the end, like Doinel, in an institution. He finds refuge, ironically, in his military service and finds himself, in the closing frames, in an overt tribute to Truffaut, running exultantly on the beach.

Les Roseaux sauvages deals similarly with the scenes and pains of adolescence. It is again in the tradition of Truffaut, but works rather as a juvenile *Jules et Jim*, and with greater sensibility. The film focuses on a group of three or four adolescents in the Lot-et-Garonne in the 1960s. The main protagonist, the moody François (played by Gaël Morel who went on to direct his own film *À toute*

vitesse in 1996) has a platonic friendship with Maïté (played by Elodie Bouchez, who also stars in *La Vie rêvée des anges*). They go to the cinema together, discuss books etc., very much in the manner of young *nouvelle vague* protagonists. Their friendship becomes confused, however, in the awakening of François's sexuality. One night in the dormitory, his straight friend Serge (played by Stéphane Rideau) comes to his bed and, in rather desultory fashion they sleep together. For Serge, this is little more than a random search for tenderness. For François, this is much more: it is the source of the questioning of his identity and an awakened desire which now goes unsatisfied for the length of the film. A turning point in the film as personal history comes in a scene which focuses issues of sexuality, identity and their visual representation. François, in a washroom, confronts his image in a mirror and seeks to define it in words. He repeats: 'Je suis pédé' (I'm gay). There seems a space between the words and his image, as there is between the face and its reflection. Téchiné shows identity as something to be named and assumed; like Truffaut or Godard, he creates a cinematic mirror stage and scene through which the protagonist attempts to pass.

Importantly, *Les Roseaux sauvages* is not primarily a film about homosexuality, however, although this becomes a convenient testing ground and test case for Téchiné in exploring adolescence and the formation of identity within and beyond social constraints. The film presents a more open view of sexualities, manifested in the camera's plural gaze (Téchiné is one of the few French directors to use two cameras on set) and its pleasure in the bodies of all its young protagonists. Téchiné, in deference to the lyrical subtitle of the series as a whole, treats the viewer to sumptuous scenes of the countryside, of sunlight on foliage and water, of the adolescents playing in the river, in a manner which appears to pay homage to the visual beauty and cinematic impressionism of, say, Jean Renoir's *Une Partie de campagne* (1936). *Les Roseaux sauvages*, as its title and reference to one of La Fontaine's fables suggest, is in part a pastoral film. (And, since the nineteenth century, French literature, and latterly French cinema, have been concerned with

questioning and maintaining this divide between urban and pastoral). Yet *Les Roseaux sauvages* is far from pastoral idyll.

The film may be enjoyed visually, and as a series of love stories, yet its theme is also far more serious. Téchiné contends with the public history of his chosen (and personal) era: *Les Roseaux sauvages* is set against the tensions and divided loyalties of the Algerian War. Maïté, the young girl, has a single mother, Mme Alvarez, who is a school teacher and a member of the PC (Parti Communiste). Their household is literally a locus of pro-Algerian sentiment since it is the PC headquarters in the town, Villeneuve-sur-Lot. Maïté is fierce in her politics. Her mother's conscience and politics are tested when Pierre, the brother of François's friend Serge, comes home on leave from Algeria. He begs Mme Alvarez to help him which she refuses to do. The scene is remarkable visually and one of the most memorable of the film. The young man has married a young girl in order to get leave in France. At his wedding, as he dances with Mme Alvarez, his former teacher, he asks her, against the music of the dance and the moving forms, to help him desert. The pace and acceleration reflect both his urgency and her indecision. Previously, communists have helped soldiers desert; now the soldiers are engaged in helping the Algerian people. Mme Alvarez's politics determine that she can't help Pierre. Their faces are seen in surprising close up through this moving scene. Soon after she has refused, he must return to Algeria and is shot. Mme Alvarez engages our sympathy as she literally breaks down in her classroom and undergoes a period of mental and physical collapse.

Téchiné shows the decisions and cost of the war in personal terms, focusing on the individual, on the intimate space of response and reaction, to reveal a larger toll. A lack of fixed view in his film is also shown in his representation of the *pieds noirs* (Algerian-born white French citizens) who return to France. His test case here is Henri, a fellow pupil of François and Serge, who obsessively listens to news of the war on his transistor radio, who we learn is separated from his mother (his father being dead) and kept back in class. A romantic irony of the film is that Henri and

Maïté, despite their opposing views, are attracted to one another. The film ends valuing the personal over the political (rather than seeking any synthesis) where they finally make love in the grass.

Les Roseaux sauvages is of course not a film about the Algerian War as such. It works instead to show the ways in which public conflict and trauma make an impact and are felt in private lives. For Téchiné, it seems, (auto)biographical filmmaking cannot be without reference to a broader frame.

2. *Coup de foudre*

Much the same point might be made about Diane Kurys's film *Coup de foudre* (1983) which is another example of a type of (auto)biographical filmmaking, this time, however, maintaining the central protagonist at one further remove from the filmmaker herself.

Up until this point the films I have looked at have been the work of male directors. It should not be forgotten that the last fifty years of filmmaking in France have seen the emergence of various female *auteurs* whose work both engages with and positively differs from the main currents in French filmmaking. Of course women had made films in France prior to 1950: a notable example is the avant-garde filmmaker Germaine Dulac who is most remembered for her extraordinary and innovative *La Coquille et le clergyman* (1927), a silent mindscape made from a 'script' by the dramatist and poet Antonin Artaud. In the 1950s, Jacqueline Audry brought a different perspective again to filmmaking, for example with her film *Olivia* (1950), an adaptation of Dorothy Bussy's novel of the same name (a work which might, despite its subversive content, be compared with the other literary adaptations of the 'tradition de la qualité'). But it was not really until the emergence of the *nouvelle vague*, in which the director Agnès Varda played a singular part, and the later development of the feminist movement in France after 1968, that women filmmakers were able to develop their own (gendered) vision with a measure of creative freedom.

For Diane Kurys, that vision, at its most successful, is intensely

autobiographical. This is witnessed in her first film *Diabolo menthe* (1977) which explores an adolescence very similar to her own in Paris in the early 1960s. The film is marked by the intense yet antagonistic relation between two sisters, by its painstaking attention to period detail: the school uniforms, plaited hair and formal classrooms, the music and dancing of the era. It is too acerbic to be a conventional nostalgia piece – which is its strength.

Kurys's career, and critical and popular success, have been chequered. The film with which she follows *Diabolo menthe, Cocktail molotov* (1980), although pursuing her autobiographical focus and turning it on the events of May 1968, seems less convincing and accomplished. Her later *Un Homme amoureux* (1987) and *Après l'amour* (1992) (in which Isabelle Huppert plays a very discontented writer in a very beautiful Paris apartment) again have been less popular. Recently, she has been working on a biopic of the novelist George Sand, featuring Juliette Binoche in the central role. Her real abiding success, however, and venture between public and personal history, is *Coup de foudre* (1983). This film stars two of the key French actresses of 1970 and beyond: Isabelle Huppert and Miou-Miou. Huppert's image is one of tranquillity and self-possession (celebrated in a special number of *Cahiers du cinéma* in March 1994). She stars in Claude Goretta's *La Dentellière* (1976) and in Maurice Pialat's *Loulou* (1979) as well as in many other films. Both actresses worked together previously in Bertrand Blier's outrageous *Les Valseuses* (1973). Miou-Miou who seems sexier and more knowing as an actress is particularly effective in the title role of Michel Deville's *La Lectrice* (1988). The two actresses complement one another perfectly in *Coup de foudre.*

This film takes as its focus the life story of Kurys's mother. This perspective at one remove is significant since the film leads us to think about how far we can know or recreate another's life and point of view. Kurys creates memory images, yet these will necessarily always be partly fantasies, a projection of the past, rather than its rediscovery (if this itself were ever possible). That the subject of the film should be her mother's sexuality and search for freedom, locates the material here firmly in the context of Freud's

notion of the primal scene: the scene viewed or imagined by young children of their parents making love, a scene which is seen to reflect the origins of the self. Some critics argue that as we view films we find ourselves re-creating this early experience or fantasy, a scene in which we are implicated and yet from which, necessarily, we are excluded). *Coup de foudre* takes us to the psychic bases of identity, yet it also makes history, and the historical mapping of the individual, its particular subject.

Coup de foudre has two time scales. The first part of the film pre-dates the birth of the child who is the alter ego of the director herself. It also pre-dates the meeting of the two women whose love at first sight (or 'coup de foudre') will be the major subject of the film. The film begins in the last years of the Second World War showing Léna (Isabelle Huppert) in a prison camp where she meets her husband, and Madeleine (Miou-Miou) at artschool where she will see her first husband and fellow art student killed in crossfire. The early scenes function as a type of pre-history: they hold explanatory function and work as a reminder (just like the memories of the war in Martine Dugowson's *Mina Tannenbaum*, 1993) of the ways in which the war itself casts a shadow over the lives of the daughters who offer a perspective on their mother's experiences.

The main action of *Coup de foudre* takes place in 1952 in Lyon. The film works well as a retro piece, exploring in loving terms the very fabrics and textures of female life in the 1950s. This is significant in the emergence of the friendship between Madeleine and Léna. They meet after a school play where they are both waiting to collect their children (Madeleine has a mournful son, René, Léna has two daughters). The two women's first response to each other is tactile and very feminine. Madeleine holds her hand to Léna's face so she can smell the scent of her skin cream. Femininity becomes a means to intimacy as both women are seen to find relief and understanding in their friendship which they do not find with their husbands, whom they have married too quickly in the confusion and aftermath of the war.

Some critics read the relationship between Madeleine and Léna

as a lesbian relationship. The film has some currency in these terms. Yet its ambiguity itself is all the more significant and makes it a subtler work. The film creates images of its protagonists' sexuality which classes them as subversive or excessive: as they lie in the grass in one scene the image is reminiscent of Courbet's painting of delicately dressed prostitutes, *Les Demoiselles de la Seine*. Léna's husband, Michel, accuses his wife of being a *gouine* (dyke), but from him this seems as much an act of aggression as a statement of fact. Indeed the ambiguity surrounding Léna's sexuality seems apt given that it is the daughter's (barely judgmental) perspective which directs the film. The two little girls are hard to tell apart in plot and action, yet time and again we are reminded that this is a daughter's perspective on her mother. That perspective is two-fold, encompassing a child's anger, guilt and fear at the break up of the family, and an adult's (feminist) acceptance of and even pride in her mother's discovery of freedom and difference.

The film avoids representing any literal sexual relations between the two women. The viewer is kept guessing, as the child herself appears to remain unsure. What the film does lay bare, and with extraordinary intensity, are the intimate scenes of family life. This attention to the domestic detail of family love and hatred is witnessed too in Sandrine Veysset's *Y aura-t-il de la neige à Noël* (1996) or in the flashbacks of Cédric Klapisch's *Un Air de famille* (1996). In *Coup de foudre* there is a scene where Léna and her husband are in bed in the morning playing with their daughters. Léna is cuddling up with Sophie, the younger daughter. Michel plays a lift game with Florence. The scene is not apparently sexualised, although my earlier comments about the primal scene might inevitably place it in this context. Indeed Léna says to Michel: 'Pas devant les enfants' (not in front of the children) as she discourages him from touching her. The scene works instead to develop and map the attachment between the children and their father in particular. Kurys evokes sympathy for Léna, her protagonist, and shows Michel to be prone to destructive rage (as when he tears down the fittings of the dress shop Léna and Madeleine run between them). Yet he is evidently loved by his daughters too, and

there is much poignancy in the final scene by the beach at Cabourg where Sophie (now located as source of the narrative) watches her father weep.

As critics have commented, Kurys has been very dismissive about being categorised as a woman film director or maker of women's films. Such labelling can be reductive, and it is true that her films do not offer an undiluted feminist perspective. Her achievement, nevertheless, has been to offer films which make the intimate dramas of women's lives their overt subject in a way which has barely been attempted by male filmmakers. Hence her films' appeal, to women viewers and others, and their importance in opening up personal and historical views on the experiences of women from the war onwards.

3. Mourning Films I

Another woman director, whose career so far has been longer and more distinguished critically and aesthetically than Kurys is Agnès Varda. She has been making films since 1956 and is the only woman director closely associated with the *nouvelle vague*. Her filmmaking has been varied, constantly self-questioning and innovative. It is in these terms and in the singularity of her vision that she is really marked out as an *auteur*. Auteurism, and the relation between *auteur* cinema and autobiography is the subject of the film I want to look at in detail in this section: *Jacquot de Nantes* (1991).

Varda's first popular and critical success came with her film *Cléo de 5 à 7* (1962). This offers an illusion of real time: the two hours of the film's duration exactly match two hours in the life of the protagonist (although of course the filming itself took far longer). These two hours are significant for Cléo, the eponymous protagonist, a fêted singer. Two hours from the start of the film, she will receive the results of medical tests. At times the film is surprisingly light, even frothy in setting and tone, to counterbalance the essential anxiety and morbidity by which it is motored. *Cléo de 5 à 7* reveals Varda's interest in mortality and fate: protagonist and film-

maker alike wrestle with death, its anticipation and the possibility of placing this in images. Varda explores an iconography of death, taking her cue from the Tarot cards and their macabre skeleton which figures in the film. This exploration of death becomes an auteurist trait in Varda's filmmaking. The obsession becomes rapidly personal in *Jacquot de Nantes* where Varda makes a film about her husband, the filmmaker Jacques Demy shortly after his death. The film works as both public and private tribute.

Jacques Demy made his first feature film *Lola* in 1961. (François and Maïté go to see the film in *Les Roseaux sauvages*.) *Lola* is set in Nantes, making the town an alternative to Paris which is favoured as setting by so many *nouvelle vague* directors (see Chapter 7). In its black and white cinematography, with camerawork by Raoul Coutard (who worked with Godard on *A bout de souffle*), *Lola* reflects a *nouvelle vague* aesthetic. Demy moved quickly from black and white to exuberant colour, using acid, intense primary shades, as in the pink, yellow, crimson and blue of *Les Parapluies de Cherbourg* (1964) for example. (Critics have remarked on Demy's influence on Almodóvar in use of colour). *Les Parapluies de Cherbourg* is perhaps most significant as a regeneration of the French musical genre. Although it tells a resolutely realist tale of unwanted pregnancy, starring a wonderful Catherine Deneuve, all the words of the script are sung by the protagonists. (An interest in replaying the musical and mixing genres can also be witnessed in Godard's *Une femme est une femme,* 1961).

Varda replays many extracts from Demy's films in *Jacquot de Nantes* making us question how films (of an *auteur*) stand as or indeed in the place of memories or personal histories. *Jacquot de Nantes* is a multilayered and self-reflexive work which asks questions about the relation between film, memory and death. Parts of the film offer footage of Demy shortly before his death. The camera works like a visual caress showing parts of his body in extreme close up: in one sequence of images the camera focuses first on his grey hair and then moves over the skin of his forehead to focus on his eye, evidently framing the part which sums up his role as director. Varda celebrates the potential of cinema to offer

an illusion of life, a moving representation of the subject even after his death. Here she comments obliquely on what has been seen by some theorists (for example Roland Barthes and Christian Metz) as an inherent property of a photographic medium. In his book on photography, *La Chambre claire*, Barthes includes a photograph of a young assassin, together with the caption: 'Il est mort et il va mourir' (he is dead and he is going to die). Since the photo dates from 1865 of course we know the young man is dead. As an assassin condemned to death his demise is already pre-inscribed: he knows it himself. The camera offers a trace, an illusion of his living presence nevertheless, yet even that is always stilled, always something from the past.

In cinema there is never complete coincidence between the moment of shooting and the moment of viewing, as Christian Metz comments. There is always a temporal *décalage* (shift) between the actions we view on the screen and our moment of viewing. In this way photographic images are inherently commemorative; this status is intensified further when the subject viewed is not merely an individual in the past who lives still, if differently, in the present, but an individual who has died. Perhaps the commemorative capacity of the photographic image explains why film has been such an apt medium in which to explore the thematics of mourning. This is shown very vividly in Pascale Ferran's brilliant first feature *Petits arrangements avec les morts* (1994) or Jacques Doillon's harrowing *Ponette* (1996). Cinema can offer an illusion of animation, even within an acknowledgement of loss and death.

This is what Varda achieves in *Jacquot de Nantes*. The film seems a mourning piece, as if the director herself is working through and rendering through art her love for her husband, her grief at his loss and her admiration for his films. As well as offering literal close-up present-day images of Demy, of his late paintings, of his conversations with a grandchild, Varda offers several past time planes in her film. The main body of the film is made up of black and white fictionalised visual narration of Demy's childhood, taken from his own accounts of his childhood memories. Three different boys of increasing ages play the child Demy as he grows from

Jacquot to Jacques and develops his vocation as a filmmaker. While showing the family background in a garage in Nantes, the effect on family life of the Occupation and the subsequent post-war years, the real focus of Varda's drama is on Demy's development as *auteur*: he is absolutely driven by a love of cinema and a desire not merely to be a spectator but to make films himself. Hence the importance of his first ownership of an amateur movie camera, his first animations – entirely painstaking with a paper cut-out ballerina – and a more complex drama with a thief, complete with cardboard scenery and animated close ups.

Varda shows the time, patience and commitment of the infant film director as she represents her husband's personal history. She shows the ways in which Demy from his very earliest childhood was animated entirely by his need to make moving pictures. This is seen also to determine his relation to the world he sees around him. The film shifts continually between these fictionalised sequences of the past and clips from Demy's films. This frequently entails a shift between black and white (for the past) and colour (for the clips). Varda occasionally uses colour photography for the past sequences too, often at moments of particular intensity. To mark the shift between the past sequences and film clips, Varda often uses a close-up of a hand pointing. As viewers we feel that Varda herself is a fairly constant presence in the film. Her voice can occasionally be heard in voice over, explaining in retrospect. She signals the construed status of the film as memory piece.

The novelty of the film lies in the way it creates a personal history of another director, showing both the accessibility and the inaccessibility of the past. Varda films literal relics from Demy's life, showing the elderly Demy, for example, holding the camera he used as a child. In some ways the film works to deny the loss of the past, to show its presence in objects and memories. Varda appears to offer an interpretation of Demy's films as mnemonic and autobiographical, cutting as she does between her cinematic evocations of his past, say the famous arcade in Nantes, and his feature film images of similar events and locations, in this instance in *Lola*. Some would dispute the notion that Demy's films should be inter-

preted so consistently in terms of his own life history. However the question can be turned on its head to say that whether or not Demy was inspired by his past in his filmmaking, Varda certainly is inspired by Demy's feature films in her evocation of his past in *Jacquot de Nantes*.

Rather than depending on this type of personal reading, *Jacquot de Nantes* seems to gain weight and interest as it enters wider debates. Varda, unlike Kurys, has been more committed in her position as a feminist filmmaker. This is witnessed substantially in her film *L'Une chante, l'autre pas* (1977), which offers an account of two women's friendship and a fictional exploration of the development of the women's movement in France. This film still holds interest and nostalgic pleasures for feminist viewers. Varda's later *Sans toit ni loi* (1985) continues to offer a feminist message and has been very successful.

As well as reflecting on feminism, *L'Une chante, l'autre pas* also offers an internal discourse on photography and the imaging of women, showing many still photographs in its opening frames. Varda has been much concerned with the ways women are represented photographically and this is shown very well in her later avant-garde films such as *Jane B. par Agnès V.* (1987), a close-up portrait of Jane Birkin. Varda's camera closes in on Jane Birkin and her body. In *Jacquot de Nantes*, filming the body of her husband, Varda seems implicitly to open a different space for the representation of the male body and to show that the eye of the camera need not work to objectify (or degrade) the subject it views. (I will return to these issues in the next chapter). Equally Varda offers a new filter for viewing Demy's films and she reveals a 'monde enchanté, finding a pleasure in imaging and in the female body which is infectious, but not noxious.

Varda pursues her own auteurist concerns in *Jacquot de Nantes*. Her personal history as director is not overwhelmed by that of her husband whose story she tells. Implicitly, since she herself is never a fictional subject in the film, Varda celebrates a partnership and the mutual creative development of two individual directors.

4. Mourning Films II

Where Varda creates a film to commemorate her husband, Cyril Collard in *Les Nuits fauves* (1992) creates a film to commemorate himself. Whether Collard's only feature film will hold lasting appeal remains to be seen. It is true however that the film has marked the 1990s in France, emotionally if not visually. The commercially available French video of the film describes it as 'le film culte d'une génération' (the cult film of a generation). The conditions of production and reception of the film make it largely difficult to view with any degree of objectivity. In every sense *Les Nuits fauves* is a personal history.

Written, directed by and starring Cyril Collard, the film explores the life of its protagonist Jean who, we learn early, on is *séropositif* (HIV+). One of the first scenes of the film takes place in a clinic where a medical assistant examines Jean and takes his blood. This is the context Collard provides for the film. Its shock effect and pathos derive from the fact that the context is not fictional. Collard himself was HIV+ when the film was made and died soon after the film came out. In this emotive context the film went on to carry off four César awards in 1993, including best film and best first film. René Prédal suggests that *Les Nuits fauves* has become a cult film for these various reasons, rather than on artistic value alone (and it is clear that he does not rate this very highly). He suggests that 'la jeunesse' have been seduced by the protagonist's vital energy, his fighting spirit and his desire to hold on to life through cinema.

It is this interrelation between life and cinema which, in my view, is the interest of the film. *Les Nuits fauves* avoids melancholy at all costs. It depends on fear of mortality and works in retrospect as a mourning film. Yet its ethos and aesthetic is anything but that. It has been described as a hymn to life and it works to offer its own accelerated message about living life to the brink, negating fear. One risk of the film, and risks are various, is in the almost hagiographic representation it offers of Jean as played by Collard. The camera comes uncomfortably close to idolising and idealising Collard's face and body. He comes to stand as a latter day St

Sebastian. His acting style is highly self-conscious. He works to isolate himself from those around him, as his directorial style encourages his camera to do the same. Frequently Jean is seen smiling, face-on or in profile. His image is silhouetted against a panoramic view of Paris, against a sunset, against the sea. Were it not for the pathos of the real drama of loss that the film both denies and recalls, *Les Nuits fauves* would seem impossibly narcissistic. There is a love affair between camera and character which the viewer, of either sex, is encouraged to identify with, from a distance.

A further problem and interest of the film is its stance on responsibility. Shaking off rigid definitions of sexuality, Collard creates in *Les Nuits fauves* a drama of an *amour fou* between a young would-be actress Laura, played superbly and with due hysteria by Romane Bohringer, and Jean, the film's protagonist. Laura is only seventeen. She is impulsive, passionate and precocious. She precipitates herself into a sexual relationship with Jean where he has treated her more like a child. He gives her a large toy dog, for example, *un chien-loup* since she has commented on le *chien-loup* (twilight) when they first meet. She plays between innocence and experience in a manner familiar in French cinema and familiarly disturbing (consider Vanessa Paradis's younger role in Jean-Claude Brisseau's embarrassing *Noce Blanche*, 1989, or Natalie Portman's in Luc Besson's *Léon*, 1994).

The shock of *Les Nuits fauves* is that Jean has unsafe sex with Laura. The film is ambiguous in colluding with this. Rightly we are shown Laura's fury as she discovers the risk he has created for her. Yet she is also willing to sleep with him again without protection, seeing this as her means of sharing everything with him. This is shown as a mad point of view in the film, and Laura all too literally loses her mind in her love for Jean. Yet both Laura and Jean may seem dangerously seductive to viewers seeking a point of identification. Jean is seen to desire Laura because she offers an image of something unspoilt and innocent: he feels like a teenager again with her.

While the film is very graphic, and gritty, in representing Jean's

gay encounters and his desire for Samy, its weak point is the straight relationship which really forms its central subject. *Les Nuits fauves* falls victim to the idealisation of this relationship of which both Jean and Laura are guilty. The film attempts at points to show the fragile base and impossibility of their love. Yet in its overly artistic coda, and in Jean's late love letters to Laura, his desire to learn about fidelity and true love from her, *Les Nuits fauves* becomes too easy and too deceptive. As a whole Jean's vision is indulged too much. Yet this is perhaps inevitable. The love story within the film is shown to be a means both of living life to the full, and of escaping mortality. The making of the film as love story, diverging from the brute reality of personal experience, again seems to serve this purpose.

Les Nuits fauves is a self-conscious film in the way it reflects on its conditions of production and also on the very act of filming itself. Jean meets Laura because she is coming for an audition for a pop video. Her image is seen through the viewfinder of his camera as he first looks at her and makes her the centre of his vision. Collard's own style as a director often imitates the style of adverts and pop videos, particularly in the use of accelerated images of fast cars, loud music, rough handheld camera work. The effect is slick and raw at once. Prédal, despite his reservations about the film, marks it out as one of those which set the tone in the early 1990s and which offered a new idiom (however derivative) to young directors.

Collard makes something different of the (auto)biographical film. *Les Nuits fauves* is a testimony which uses the body of its director and principal actor as its guarantee of veracity. The film lacks the artistic vision and, more importantly perhaps, political commitment of Derek Jarman's re-working of cinematic (auto)biography in the face of AIDS in *The Garden* (1990) or *Blue* (1993) for example. Yet Collard, together with the writer Hervé Guibert, is directly or indirectly responsible for making AIDS a subject of urgency in France and the French media. Again a very personal history serves a public purpose at a very particular moment in history. (Auto)biographical filmmaking is about much

more than recording a life history. In their various visual narratives of identity, desire and mortality, French directors have very diversely re-thought the possibility of film as medium in which to trace, and keep, a destiny, to let it be seen.

Selected Reading

Roland Barthes, *La Chambre claire* (Paris, 1980). In French. Barthes's last book and a moving discussion of photography, and the nature and effect of the photographic image.

Gilles Médioni, *Cyril Collard* (Paris, 1995). In French. A lively, biographical volume on Collard.

Alain Philippon, *André Téchiné* (Paris, 1988). In French. A volume on Téchiné in the excellent *Cahiers du cinéma 'Auteurs'* series. Given its date, it does not cover *Les Roseaux sauvages*, but offers a good introduction to the director's earlier work.

Alison Smith, *Agnès Varda* (Manchester, 1998). A clear introduction to Varda. Particularly interesting on memory in her films.

Camille Taboulay, *Le Cinéma enchanté de Jacques Demy* (Paris, 1996). An excellent introduction to Demy's films. This would complement study of *Jacquot de Nantes*.

Carrie Tarr, *Diane Kurys* (Manchester, 1998). Forthcoming.

Agnès Varda, *Varda par Agnès* (Paris, 1994). In French. A wonderful illustrated volume on Varda's films.

Films

Les Roseaux sauvages: Cahiers du cinéma, no. 481 (June 1994), pp. 7-17; *Sight and Sound*, vol. 5, no. 3 (March 1995), p. 50.

Coup de foudre: Cahiers du cinéma, no. 347 (May 1983), p. 72; *Monthly Film Bulletin*, no. 598 (November 1983), p. 301.

Jacquot de Nantes: Cahiers du cinéma, no. 445 (June 1991), pp. 50-52; *Sight and Sound*, vol. 1, no. 10 (February 1992), pp. 47-48.

Les Nuits fauves: Cahiers du cinéma, no. 460 (October 1992), pp. 20-32; *Sight and Sound*, vol. 3, no. 6 (June 1993), pp. 24-25, 62.

3

Love Stories I: *L'Amour fou*

Les Nuits fauves is typical of French cinema as love story: it presents an *amour fou*. This ideal of passion haunts French cinema's representations of desire and may be seen as a strange legacy of the Surrealist movement in post-war French culture. Consider André Breton's desire for the elusive Nadja, protagonist of the text of the same name, incarcerated in an asylum by its close. This obsession with *amour fou* is symptomatic of a broader representation of femininity in French cinema. Femininity is defined as what is desirable, alluring and elusive at the same time. French cinema engages in a perpetual chase to capture the perfect in desire, yet that perfection is found in impossibility. Hence the supposed appeal of *amour fou*. Can it ever be lived out rationally in the bourgeois family house? Can it exist outside rigid gender role play? In this chapter I want to explore various, divergent examples of transgressive passion, questioning ways in which recent films might offer a different take on *amour fou*.

1. 'Une sensualité lumineuse'

In *Les Mistons* (1957), Truffaut's first (short) film, a band of preadolescent boys become obsessed with a young woman Bernadette (Bernadette Lafont). They take a prurient interest in her affair with their gym teacher Gérard (Gérard Blain). Bernadette is filmed first cycling through the countryside near Nîmes, her skirts flowing in the sunlight. The voice-over narrative tells us that she marks the discovery of 'une sensualité lumineuse' in the lives of the boys. This becomes the 'sensualité lumineuse' of the *nouvelle*

vague, derived in part from the influence of Jean Renoir, yet attached specifically in the *nouvelle vague* to young women, their image and their sexuality.

The director who has done most to maintain this image of 'sensualité lumineuse' as the essence of cinema and filmmaking is Eric Rohmer. His films, and work in *Cahiers du cinéma*, associate him with the *nouvelle vague*, although he is in fact slightly older than the generation of young critics such as Godard and Truffaut. Rohmer began making films in the 1950s. His first great success, however, was with *Ma Nuit chez Maud* (1969), a film about morals and philosophy, set in Clermont-Ferrand (the birthplace of Blaise Pascal). As in so many of Rohmer's films, the main subject of *Ma Nuit chez Maud* is its protagonist's self-delusion. Gradually through the film, and in a wonderful moment of revelation on the beach, the protagonist, Jean-Louis, is seen to be the dupe of his own illusions. These surround Françoise, a young woman he encounters in the street and at mass, who embodies for him the ideal Catholic blonde. He centres his affections on her, and later marries her.

In Rohmer's films, desire, and relations between men and women, become the focus of broader debate about morality, chance and responsibility. He takes a personal history, and central protagonist, on whose amorous encounters (frequently unsuccessful) he focuses these questions. Rohmer is central to a certain tradition of French filmmaking which depends on the imbrication of intellect and desire: his influence is felt in more recent films such as Philippe Harel's *La Femme défendue* (1997) and Arnaud Desplechin's *Comment je me suis disputé (ma vie sexuelle)* (1996).

But Rohmer himself continues to make films. He is most famous for his various series of films: the *Contes moraux* (1962-72), of which *Ma Nuit chez Maud* is a part, the *Comédies et proverbes* (1980-87), amongst which are found *La Femme de l'aviateur* (1980), *Les Nuits de la pleine lune* (1984) and *Le Rayon vert* (1986), and most recently *Contes des quatre saisons* (1989-98), a series of films which was completed with the release of *Conte d'automne* in Paris in Autumn 1998.

Rohmer's films give women a prominent place. Yet Rohmer's

approach to women is ambiguous. On the one hand, more than any other male director of his generation, he uses central female protagonists and frequently makes the vagaries of (female) desire his subject. This is found palpably in *Les Nuits de la pleine lune* where Louise, played by Pascale Ogier, circulates indecisively, and rather at her own cost, between three different men, only to end up with her platonic friend, Octave (Fabrice Lucchini). Rohmer's films show that both male and female protagonists can be indecisive, misguided and selfish in desire. Louise finds her match, for example, in the male protagonist of *Conte d'été* (1996).

However, what differs in Rohmer's approach to male and female protagonists is his aesthetic (if not erotic) interest in the female body and in its imaging. This is self-consciously Rohmer's subject in a film such as *Le Genou de Claire* (1970) where the film explores its protagonist's obsession, precisely, with Claire's knee. In the later *Pauline à la plage* (1983), Rohmer further renders this interest self-reflexive as he focuses on illicit viewing, showing for example a window frame through which a young girl is viewed within the frame of the shot. In this film Rohmer creates pictorial tableaux worthy of the artist Balthus. In other films where he focuses on young girls' friendships, using a series of girlish and ethereal actresses (see *Quatre aventures de Reinette et Mirabelle* (1986) or the first part of *Les Rendez-vous de Paris*, 1994) Rohmer seems to associate himself with a Proustian tradition, working almost always 'À l'ombre des jeunes filles en fleurs' (in the shadow of young girls in bloom).

The film I will look at in detail escapes the aesthetic idealism of much of Rohmer's filmmaking. It is, nevertheless, a narrative of an *amour fou* and works indeed as a cinematic fairy tale. *Conte d'hiver* (1991) is the second in the series *Contes des quatre saisons*. It stars Charlotte Véry as Félicie, a young hairdresser in Belleville. In this focus Rohmer seems to recall Claude Goretta's *La Dentellière* (1976), an adaptation of Pascal Lainé's novel. In *La Dentellière*, Isabelle Huppert plays a young girl who works in a beauty salon, whose innocence and stillness are likened to Vermeer's painting of a lacemaker (which hangs in the Louvre). Rohmer's Félicie is far

stronger in character, however, and her strength of will is one of the film's major subjects.

Conte d'hiver opens unusually with a montage of images of a couple in the summer, at the beach, making love in the country-side. This relationship is silent as we view it in an accelerated sequence. It takes the place of establishing shots in the film. Rather than setting *Conte d'hiver* firmly in a particular location (although Paris, its suburbs and Nevers in the Loire will later be its loci), Rohmer sets the film in an emotional space, the space of a love affair that has been left behind. Quickly the sequence comes to a close and the action begins five years later, in winter, in Paris. The pace of the film slows to become a visual diary. As often in his films (such as in *Conte d'été*), Rohmer uses intertitles giving the date as days go past. *Conte d'hiver* takes place between Friday 14 December and Monday 31 December. This temporal context seems important for the film to show the freak development in the personal history of its protagonist.

Félicie has a complex emotional life: the film shows her moving between its various points of contact. She has been having an affair with the older owner of her salon, Maxence. He decides to leave his wife and move to Nevers, hoping to take Félicie with him. She is also involved with a young librarian, Loïc, who loves her desperately, but leaves her feeling 'diminuée' (belittled) – her words. In Maxence and Loïc, Rohmer realises a standard division (in his films) between a man of the senses and a man of the intellect. Félicie fails effectively to choose between them, though her impulsiveness will lead her to follow Maxence to Nevers. This is an excuse for a wonderful visual promenade through the town, recalling the French location of *Hiroshima mon amour* (see Chapter 5). Félicie leaves Maxence almost as quickly to return, halfheartedly, to Loïc.

The third player in her emotional drama is her daughter Elise who is brought up in part by her mother and who is the living reminder of the love affair the viewer glimpsed in sunny flashback at the start of the film. Félicie has lived an *amour fou* with Charles, who embodies her male ideal. Yet by a random slip they lose con-

tact. After their summer passion, Félicie gives Charles her address as they part at the station. By accident she gives her address as Courbevoie, though she lives in Levallois. Charles can never write to her, and their relationship seems necessarily at an end. She lives the next five years idealising their love and bringing up the daughter they have conceived.

The wager of the film, its risk and its pleasure, is in the gift of chance it gives Félicie. Rohmer lets the film lift out of the bounds of realism. True to his Catholic origins perhaps, he rewards Félicie for her faith. Late in the film she goes to see a production of Shakespeare's *A Winter's Tale* (a self-conscious intertext in the film). Félicie knows nothing of the play before she goes. As viewers we see her watching Hermione recovered. Félicie is seen to cry (resembling Anna Karina watching Falconetti in Godard's *Vivre sa vie*). Loïc and Félicie talk about the play afterwards. He comments that what troubles him about it is that one never knows whether Hermione was really dead and is brought back to life by magic, or whether she never really died at all. Félicie claims straightaway that he has misunderstood and that faith is what restored her to her loved ones. The film seems to authenticate her view. Very shortly after this, she is sitting in a bus in the outskirts of Paris. Here by chance she encounters Charles, her seaside lover. The viewer is treated to the recognition scene in shot-reverse shot editing as the protagonists become aware of each other.

Rohmer takes the risk of a fairy-tale happy ending. Félicie finds all she has wanted in Charles. He matches the image she has preserved of him as even Elise, who has only known his photo, recognises him and calls him 'Papa'. Félicie's love for Charles is recognised as an *amour fou*. She describes herself as 'folle à lier' (raving mad). Charles is her 'prince charmant' as the film explicitly suggests. In giving us a happy ending, Rohmer alludes to the possibility of film as wish-fulfilment. Prédal makes out the influence of Jacques Demy's films in *Conte d'hiver* in particular, saying that Rohmer has internalised Demy's love of the *miraculeux*. Another point of contact might be made between Rohmer and the Polish filmmaker, Krzysztof Kieślowski who made films in France

with French funding, in the 1990s (before his death in 1996). *Conte d'hiver* recalls at certain points the seventh film of Kieślowski's *Decalogue* (1988), a bleaker film about the tension between a single mother, her daughter and the child's grandmother. For Kieślowski more generally, as for Rohmer, film can offer an exploration of chance, of order, of directed destiny, which is lacking in everyday life. The viewer is invited to suspend disbelief to experience the pleasure of films which make redemption their subject. In *Conte d'hiver*, Rohmer reveals that *amour fou* is as much the preserve of a female protagonist as of a male. He shows that her blind belief has its own rewards.

2. Betty Blue

A very different image of *amour fou* is given in Jean-Jacques Beineix's *37°2 le matin* (1986, called *Betty Blue* in English translation). This film, like *Les Nuits fauves*, quickly became a cult film for its generation of viewers. Beineix, together with Jean-Luc Besson and Léos Carax (whose work has been taken more seriously by French critics) have become associated with the *cinéma du look*. This dates back to the start of the 1980s, firstly with Beineix's *Diva* (1980) and subsequently with Besson's *Subway* (1985), *Le Grand Bleu* (1988) and *Nikita* (1990), and Carax's *Mauvais sang* (1986) and *Les Amants du Pont Neuf* (1991). Such filmmaking is typified by a concern for image and surface, speed and light (developing from the *nouvelle vague*), a new image of freedom and redemptive passion. The films of the *cinéma du look* create accelerated romances in both glossy and louche, artificial urban settings. The films have dated quickly, at risk of over-exposure when first shown, and they seem now very period specific, although they are still often very popular. *37°2 le matin* captures a moment, a mood and an image of the mid 1980s.

The image of the film is embodied in the actress Béatrice Dalle who plays the protagonist Betty. Dalle is a modern Louise Brooks, with bobbed dark hair and volatile, childlike openness. Betty is the surrealist *femme-enfant*, Zorg's muse and his object of desire. Her

role looks forward to that played with more impassivity and inten-
sity by Juliette Binoche in *Les Amants du Pont Neuf.* Béatrice Dalle
becomes an icon of femininity in the 1980s, her image in midnight
blue, against blue, in multiply reproduced film posters. Yet Betty,
the character she plays, is barely a role model in her volatile char-
acter and tragic destiny.

37°2 le matin paints a set of pictures of idealised images in soft
seaside colours: the warm interior shots of the sex scene on which
the film opens, the sky blue pink and gathering dusk of the sunset
sky, complete with saxophone accompaniment, the pale rose and
blue of Betty and Zorg's house. Beineix creates a stylised space in
which an avid passion is lived out and rendered impossible. *37°2 le
matin* is visually explicit from its start. Yet its subject is self-destruc-
tion rather than sexuality (compare this too with Patrice Leconte's
Le Mari de la coiffeuse). The appeal of such self-destructive femi-
ninity to a wide audience is disturbing. Susan Hayward argues
powerfully that *37°2 le matin* is not a film about a young girl's pro-
gressive descent into hellish madness; rather, she says, 'it is a male
fantasy of the "supreme fuck"' (p. 293). Betty destroyed by desire
is at once the woman who does not exist and a blank space, an
absent image at the centre of the screen, her illusory status con-
firmed as she is unresponsive and drugged, then suffocated by
Zorg before the end of the film.

Hayward sets the film in the context of discussion of spectator-
ship as voyeurism, arguing that 'the spectator-viewer-voyeur's gaze'
is transfixed upon Betty's sexuality. She alludes here to a set of
ideas which have gained general currency in Anglo-American film
theory (and latterly, though gradually, amongst French critics too).
In 1975, the theorist Laura Mulvey published a highly influential
article: 'Visual Pleasure and Narrative Cinema'. In this, Mulvey
argues that spectatorship has come to assume a gender split,
divided between male activity and female passivity. She looks at two
things which influence spectatorship: narcissism and scopophilia
(Freud's term for pleasure in looking). Male spectators, she sug-
gests, identify narcissistically with the male figure on screen who is
frequently shown to be the initiator and agent of action and

intrigue in film. (She is talking here about American narrative cinema of the 1940s.) Through his identification with the male protagonist, whose viewpoint he shares, and through his own desires, the male spectator is seen to take pleasure from viewing the female object of desire within the film. This is scopophilia.

This theory of spectatorship is seen to leave contradictory choices for the female spectator who must, supposedly, engage either in trans-gender identification, aligning her active gaze with that of the male protagonist, or in passive, and narcissistic identification, adopting herself the spectacular position of the female object of desire. Various theorists (notably Gaylyn Studlar, Linda Williams, Judith Mayne, Carol Clover and D.N. Rodowick) have argued against Mulvey, suggesting, variously, that a broader range of identificatory positions are available; that spectatorship is a (safe) space of fantasy rather than a space of identity negotiation; that the way we view is marked by historical, social, national and financial factors as much as by gender or sexuality. These criticisms seem important, and the general applicability of Mulvey's theories (which notably she never asserts) is much disputed. Nevertheless her essay offers a useful framework within which to consider desire in spectatorship and our own positions of identification.

What may be interesting about *37°2 le matin* is the pleasure it has given a generation of female viewers who, I would argue (extending the qualms of Hayward's discussion) have found in Betty as played by Dalle an object of erotic fascination. In Mulvey's schema this might suggest that female viewers are complicit with the passive position of the female object of desire who is revealed, all too explicitly in *37°2 le matin* to be both self-destructive and masochistic. Yet I would suggest that this is not expressly the case in this film. In the figure of Béatrice Dalle, in keeping with the aesthetic of the *cinéma du look*, image is everything. *37°2 le matin* has allowed (young) female spectators to explore an image of female beauty and eroticism. In the film itself this image is pathologised in a way viewers may regret (though this doubtless also adds pathos to Betty's allure). The image of Béatrice Dalle is important in the 1980s context where in consuming popular culture, women are

beginning to deny the division between identification and desire (on which a theory like Mulvey's is built). Within heterosexual identification, female images of desirability can still be an object of female fascination. This may be liberating rather than masochistic. Consider Madonna and her role in *Desperately Seeking Susan* (1985), a film which explores female friendship. Arguably Madonna is both a role model and object of desire for the female viewer (this possibility is exploited further in Madonna's music videos). In *37°2 le matin*, Betty's sexuality, her passion, her body, her wardrobe become an object of female fascination.

It is a tricky view to hold, but I think that Beineix in *37°2 le matin*, like Besson in *Nikita* (as we shall see in the next chapter), whatever their overt gender politics, may offer pleasure for the female viewer. This pleasure offers a different engagement in the *amour fou* of which the female protagonist is all too frequently a victim. Beineix's *amour fou*, despite its retrograde close, is a space of new identifications, and a new look in cinema. Overtly devoid of political comment or social engagement (one of the frequent criticisms of the *cinéma du look*), his films, against themselves perhaps, can offer subversive pleasure to their viewers.

3. Comedy and Transgression

In the late 1980s and 1990s, the representation of transgressive love has become increasingly focused on social issues which bring with them questions of inequality and prejudice. French cinema has typically dealt with these issues through comedy rather than realism, thus ensuring that the audience remain entertained, even when their values and prejudices are questioned. In the final part of this chapter I want to look at two comedies of the last decade which offer their own social comment and a love story reviewed. Both are the work of women directors.

Gazon maudit (1995) was a surprise hit at the French box office. (The title of the film literally means 'cursed lawn' and refers to a colloquial French expression for the female pubic hair.) It was second only to *Les Anges gardiens* in numbers of seats sold in 1995.

With an international star (Victoria Abril) it exported well, in the UK at least. Its director Josiane Balasko, has long been a central figure in French comedy, but as actress rather than filmmaker. She grew up in the *café-théâtre* tradition of French comedy. This style of comedy is typified by directed social comment, naturalistic humour and a certain sexual freedom. Stars of the *café-théâtre*, many of whom have latterly turned to the cinema, are Coluche, Thierry Lhermitte and Miou-Miou. The influence of *café-théâtre* is felt in French cinema from the 1970s onwards, in particular, for example, in the work of Bertrand Blier, an extraordinary and testing director whose work makes (sexual) transgression and the transformation of gender roles its trademark. This can be witnessed in his films from *Les Valseuses* (1973), through *Tenue de soirée* (1986), to the shocking *Mon Homme* (1995). Josiane Balasko stars in Blier's tamer *Trop belle pour toi* (1989). She plays a supposedly plain secretary with whom her boss, played by Depardieu, becomes involved, in preference to his wife, played by Carole Bouquet. The film was an international hit, and with good reason. It offers an acerbic account of sexual mores, disconcerting scenes where the protagonists speak directly to camera, and a score dominated by insistent Schubert striking exactly the tone of Depardieu's *amour fou*.

Balasko stars in her own hit, *Gazon maudit*, as well. Her image is much changed from the Blier film. In *Gazon maudit* she plays Marijo, a butch lesbian, with much aplomb. As Ginette Vincendeau (1996) puts it succinctly, in *Gazon maudit*, '[Balasko] turned a lesbian comedy into a family film and box-office hit'. No mean feat. Balasko contrived to please the French public, yet also to win the approval of the lesbian community and press. *Gazon maudit* has a lightness of touch which risks frivolity, yet achieves universal appeal.

Sexual transgression has long been a part of French comedy and Balasko takes a standard set up of the popular genre: a *ménage à trois*. Her subversion is to explore relations between a husband, his wife and her (female) lover. Laurent and Loli are seemingly a conventional young couple in the Midi, raising their two children

in a sunny respectable home (locus of much of the action of the film). Loli, played by Victoria Abril, is Spanish. She is cast as the perfect feminine housewife, her hair long and curling, her dresses short and girlish. In the first scene in the home we see Loli doing the housework, dusting her wedding photos and looking after her children. This idyll of heterosexual happiness is doubly disrupted, however. In one of the early scenes of the film we have seen Laurent at the local café, courting the women of the neighbour-hood and generally acting the philanderer. At night Loli, naked and sensual, tries to seduce him, but he turns over in bed pre-tending exhaustion. The situation is ripe for change. Into this *ménage* walks Marijo whose van has broken down outside. She quickly becomes the figure who is missing in Loli's life. Her gender role is ambiguous, while her sexuality is unmistakable.

In the opening shots of the film we have literally shared Marijo's point of view. Josiane Balasko films from inside a van which she is driving so that the frame of the window is within the frame of the film and we, like Marijo, see the sexy pictures of women she has on her windscreen and the road which is coming up in front of her. The van goes into a long tunnel and as it emerges, new music plays over the soundtrack: 'A Whiter Shade of Pale'. The welling music sets the tone of the film as the landscape too rapidly evolves. A sunlit idyll unfolds. We have been placed to be at one with Marijo, to share her angle of vision and her viewpoint. Yet also importantly in the film we are encouraged to see her as a stranger, whom we will begin to get to know. When she arrives at Loli's house she appears silhouetted in the doorway. She is greeted by Loli's son saying: 'Maman, c'est un monsieur' (mummy, it's a man). While Loli responds to Marijo as a woman, not a man, nevertheless Marijo's ambiguity is significant as the scene unfolds. She will fix the sink for Loli in a supposedly masculine gesture, slick back her hair and zip up her jeans. She seems to parody a male gender stereotype. Balasko plays at first for laughs. Yet a point is made as the film seems to show up the falseness of fixed gender roles and of fixed distinctions between masculine and feminine.

This is achieved at the level of filming and in visual terms too. It

is already partly transgressive for Balasko herself to be director of a comedy and to be adopting a traditionally 'masculine' role in the French cinema industry. This is complemented and corroborated by the position she takes up in her role as Marijo: active protagonist and desiring viewer. Balasko confounds the heterosexual stereotype explored and theorised by Mulvey (see above). She works within a convention of fixed viewing relations. Her achievement is to change its terms from within and to question how we can accept a woman as both subject and object of the gaze. Little that is radical is achieved in the choice of Victoria Abril as (visual) object of desire. Her body, its clothes and movements, embody a hyperfeminine ideal. Perhaps it is all the more subversive however to explore how this ideal may exist beyond heterosexual stereotype. Abril's body is framed and displayed in conventional terms. Balasko uses shot-reverse shot sequences, for example, shooting a scene between Loli and Marijo where Loli reclines on the sofa, showing off her legs in her short skirt. A visually conventional romantic scene is subverted by changing the gender of one of its players.

In the first scenes between Loli and Marijo, the film lays emphasis on courting rituals and coquetry in a way which demonstrates how same sex relations may still be governed by masquerade and difference. This is revealed too in the very theatrical scene in the Spanish restaurant where Marijo and Loli dance flamenco together, playing the male and female roles respectively. Balasko seems to show up the performative aspects of gender role play in hyperbolic terms. Yet at other points the film comes closer to resembling earlier French films about female friendship and desire (such as L'Une chante, l'autre pas and Coup de foudre) by showing that what Loli and Marijo share is an intimacy and understanding which cuts across this masquerade of desire. The film avoids overt voyeuristic pleasures for its audience by leaving out any explicit lesbian sex scenes. We are given instead scenes of intimacy: the two women lying in the bath, or on the beach. We are shown their conversations and the comfort they give each other.

This is important politically and sexually. Balasko takes a stereotype that some find alienating: the butch lesbian. The stereotype fits the fairly broad strokes of her comic style and in this way the film is immediately 'readable' by its audience. Yet Balasko then works from within to domesticate the stereotype, to make Marijo an individual, yet not to ignore her sexuality. This is achieved particularly well in the scenes in the latter half of the film where Marijo's ex and her girlfriend come to stay in the house. Here Marijo's past and sexuality are explored in greater depth.

Gazon maudit plays between the insider and the outsider point of view. At the end, where a point of view shot reveals Laurent's alienation as he walks through a lesbian nightclub, it seems that Balasko shows us the type of spectacle she might have offered and reveals why she has preferred to make her point through a personal history (not her own, note, as she herself makes her heterosexuality quite clear in interviews). For some, the film's 'integrationist' approach is problematic. Remember that Vincendeau described this as a 'family film'. This is realised all too literally at the end of *Gazon maudit* where, after many plot twists and turns, Marijo returns to live with Loli and Laurent, now reunited, to bring up her baby, fathered under duress by Laurent. Balasko makes motherhood a lesbian's ultimate desire.

To give her credit, we may assume that Marijo does not sacrifice her sexuality, but this end in family values still seems troubling. Perhaps there is political efficacy in opening up the family and showing motherhood differently. *Gazon maudit* never makes political claims, yet a film which treats such a subject can hope at least to make some social comment and some psychological impact on its viewers. I would say that *Gazon maudit* achieves this. Comparison with the more burlesque gay and transvestite comedy *Pédale douce* (1996) only confirms the freshness of Balasko's film. (Although Alain Berliner's immensely touching *Ma Vie en rose* (1997) opens new paths for a comic yet heartfelt exploration of gender and sexuality).

Coline Serreau, who also benefited from a *café théâtre* back-

ground, pre-dates Balasko in her filmmaking. She too has been willing to explore transgressive topics. Her widely successful *Trois Hommes et un couffin* (1985) is an appealing narrative of male incompetence and gradual infatuation with a baby girl who is abandoned in their midst. The film has been discussed at length by Phil Powrie and Guy Austin. Serreau followed it with another comedy, this time a further *amour fou* as its parodic title indicates: *Romuald et Juliette* (1989). Here sexuality is not the taboo, but class, milieu, money and race.

Romuald, played by Daniel Auteuil, is the white PDG (*Président Directeur Général* or head) of a yoghurt company, Blanlait. He leads a suitably privileged and luxurious lifestyle with his wife and two children. Juliette (Firmine Richard) is the black cleaning lady who tidies Romuald's office at Blanlait each night. She lives on the outskirts of St Denis (we see her métro ride to St Denis-Basilique, followed by a bus ride home) in an HLM (*habitation à loyer modéré* or council flat) with her five children and none of their five fathers. Romuald quickly becomes involved in intrigue as the plot unfolds. He chooses a second in command and instructs him to increase production in a particular factory. His two rivals, Blache and Cloquet, take advantage of the situation and arrange for the yoghurt to be poisoned and a scandal to erupt. Furthermore, they scheme with Romuald's secretary with the result that Romuald is accused of insider dealing.

In this mess, Romuald finds that his guide and his saviour is Juliette. She works out what is going on and second-guesses the moves of Romuald's colleagues. Juliette collects vital evidence and puts Romuald in a position to turn the scheme on its head. Within this she accepts him in her home, gives up her bed for him and lets him hide out while he needs to. A large part of the satisfaction of the film comes for the viewer in Juliette's percipience and the slow discovery of various intrigues. Serreau underlines the injustice, class and race prejudice which determine Juliette's place in Blanlait and her social role.

In its latter half, the film develops into a romance and it is here, while still offering pleasure to the viewer, that the position it adopts

is perhaps more troubling. Romuald's wife has long been cheating on him with the second in command at Blanlait. Romuald does not realise this until late in the film. He is slowly attracted to Juliette during his stay in St Denis, but he does not act on his desire. (The most erotic moment here comes as he opens a door catching a view of her dormant naked body). When he finds out about his wife, he quickly sleeps with Juliette on the office floor. Then begins his lavish courtship of her, filling the office with flowers, buying her a washing machine and dishwasher, escorting her children to school. Juliette resists this attention for a time, importantly stressing that love cannot be bought. Yet eventually, of course, by the film's close she is brought round and, with her own set of demands, meets Romuald's desire.

The film ends with a pastoral idyll. Romuald has bought a gorgeous, white house in the countryside outside Paris. It has sumptuous gardens and a swing for Benjamin, Juliette's youngest child. Romuald and Juliette hold a lavish party where we see both Juliette and Romuald's ex heavily pregnant. Juliette has already told Romuald that their child will be called Caramel.

Romuald et Juliette has a feel-good ending. Like *Gazon maudit* it seems to celebrate motherhood and fertility as a source of reconciliation of difference and difficulty. More than *Gazon maudit*, *Romuald et Juliette* is a fairy tale and remains really a white fairy tale, without being *métissé* (mixed). Serreau creates a film which makes important comments about class, race, gender and opportunity. Yet the film is truer to Hollywood tradition than to the new cinema of the *banlieue* and of social inequality which has found a large audience in France (see Chapter 7). Serreau only subverts the tradition of the romance by making it inter-racial (not such a bold step) and by creating a heroine who is highly intelligent, determined and self-motivated.

Both *Gazon maudit* and *Romuald et Juliette* place a love story at the centre of their narrative. They make the *histoires* of a set of individuals gain resonance beyond the fixed stereotypes of comedy, coming to reflect pithily and with good humour on the social issues of the 1990s. Where I have argued that love depends on

impossibility and transgression in French cinema, comedy becomes a utopian (imaginary and ideal) space where taboos are ignored and pleasure becomes possible.

Selected Reading

Pascal Bonitzer, *Eric Rohmer* (Paris, 1991). An excellent volume on Rohmer on the *Cahiers du cinéma Auteurs* series. Given its date of publication, there is no mention of *Conte d'hiver*, but the volume provides useful background for those studying the film.

C. G. Crisp, *Eric Rohmer: Realist and Moralist* (Bloomington, Indiana, 1988). Again an earlier study of Rohmer. Particularly good on Rohmer and realism.

Carolyn A. Durham, *Double Takes: Culture and Gender in French Films and Their American Remakes* (Hanover, New Hampshire, 1998). Fascinating study of the phenomenon of the remake. Some particular discussion of Serreau.

Alexandre Grenier, *Génération Père Noël* (Paris, 1994). A journalistic account of the generation of actors and directors associated with *café-théâtre*. Some interesting background on Balasko.

Denis Parent, *Jean-Jacques Beineix: Version originale* (Paris, 1989).

Constance Penley, *Feminism and Film Theory* (London, 1988). A volume of essays on female spectatorship and women directors. It includes Laura Mulvey's groundbreaking essay, 'Visual Pleasure and Narrative Cinema'.

Eric Rohmer, *Contes des 4 Saisons* (Paris, 1998).

Brigitte Rollet, *Coline Serreau* (Manchester, 1998). A good introduction to Serreau's films, with an interesting perspective on women and comedy in France.

Films

Conte d'hiver: Cahiers du cinéma, no. 452 (January 1992), pp. 18-29; *Sight and Sound*, vol. 3, no. 1 (January 1993), p. 44.

37°2 le matin: Cahiers du cinéma, nos. 383-384 (May 1986), pp. 79-80; *Monthly Film Bulletin*, no. 633 (October 1986), pp. 298-300.

Gazon maudit: Cahiers du cinéma, no. 489 (March 1995), pp. 60-63; *Sight and Sound*, vol. 6, no. 3 (March 1996), pp. 41-42.

Romuald et Juliette: Cahiers du cinéma, no. 418 (April 1989), pp. 50-51; *Monthly Film Bulletin*, no. 679 (August 1990), p. 234.

4

Love Stories II: Thrillers

1. France/USA

In Godard's *Pierrot le fou* (1965), there is a brief appearance by the American director Sam Fuller at a Parisian soirée. Here Fuller offers a definition of cinema: 'A battleground. Love. Hate. Action. Violence. Death. In one word ... Emotion'. It may at first seem strange to look at thrillers under the heading 'Love Stories II'. But as this chapter will show, thrillers in France in the last fifty years can be understood in the context of the love/hate relationship between French filmmakers and American cinema. Further, in the battleground of knowledge and violence, deception and desire, which the French thriller becomes, a love story of sorts, however innocent or depraved, is almost inevitably at its centre.

The development of the thriller in France has depended in part on a French internalisation and re-invention of a new tradition in US cinema: *film noir*. *Film noir* is the name that has been given to a certain genre or generation of American films, dating from the 1940s and typified by crime themes, moral ambiguity, urban settings and underlit or nighttime scenes. These films, such as *Double Indemnity* (1944) or *The Big Sleep* (1946), are peopled amongst others by the hardboiled detective (who becomes himself embroiled in events) and the shimmering, steely femme fatale. In highly stylised forms, *film noir* offers a visual enactment of anxiety, pessimism and paranoia. This is the mood which begins to infect the French thriller in the 1950s. It can be seen at its height, for example, in Henri-Georges Clouzot's *Les Diaboliques* (1954) where betrayal is the fate of the spectator as much as of the protagonist

Christina played by Véra Clouzot. A film which purports to represent a murderous female couple (pre-dating such films as *La Cérémonie*, 1995, or *Heavenly Creatures*, 1994) in fact places the heroine as victim of her own plotting and dupe of the scheme in which she appears to play a part. In *Les Diaboliques*, as in other French thrillers, it is the mood itself and the suspense it breeds, which are important, over and above the direction of the plot and the dénouement of the drama. Spectatorship and the viewer's role in responding to stimuli and decoding clues become foregrounded subjects as the French thriller distinctively questions its own status as film art, and the proximity between the subject and reception of its visual narrative.

This self-consciousness is nowhere clearer than in the questioning of the relation between French and American cinema. As we have seen (Chapter 1), American cinema began readily to be consumed in France in the immediate post-war years. The effect on French film production is immediately felt and French cinema itself transformed as a result. Different critics offer differing accounts of this impact and of the interrelation between French and American cinema. Susan Hayward and Ginette Vincendeau (1996) both lay emphasis on the specificity of French cinema in contradistinction to its US (largely Hollywood) counterpart. Hayward stresses that where the *film policier* (later known more generally as *polar*) replaces melodrama as a dominant genre in French popular cinema post 1945, she argues that the adoption of thriller and gangster plots marks an effort to counter the influx of US films in France. Where Vincendeau comments that France is the only country outside the US to have built up a large and consistent body of thrillers, she emphasises links between French filmmaking pre- and post-1945, reminding us of the ways in which the crime film can already be found in French cinema (for example in Feuillade's *Les Vampires* as discussed in Chapter 1) prior to Hollywood influence.

For Jill Forbes, with Guy Austin following her lead, French directors work to imitate as much as rival American thrillers. She cites as an example Jacques Becker's *Touchez pas au grisbi* (1954).

She suggests that 'all polars have in common their reference to a genre which is ultimately American' (p. 53). Further, and more subtly, Forbes demonstrates that 'the French thriller serves to articulate France's relationship with the United States'. This formulation is important since it allows us to begin to unravel the tensions and deceptions which may be inherent in this relationship. The approach I will adopt here will attempt to keep in play questions of both rivalry and imitation (hence the love/hate relationship mentioned above).

The thriller or *polar* has proved a dominant and evolving genre in French cinema of the last fifty years, from the era of the direct influence of *film noir*, through the *nouvelle vague*, to realist and political *polars* of the 1970s and 1980s (by directors such as Costa Gavras and Maurice Pialat) through to the postmodern *polars* of the *cinéma du look* such as Beineix's *Diva* or Besson's *Nikita*. What the 1990s have proved, again opening up the question of French/American relations in cinema, is the possibility that French cinema will in turn exert its own influence on the American thriller, through the work of French directors like Besson and Kassovitz in America, for example, and through the stylistic influence of a film such as Jena-Pierre Melville's *Le Samouraï* (1967) on Quentin Tarantino's *Reservoir Dogs* (1991). The question of relations between US and French cinema was brought to a head in the negotiation of the GATT trade agreements in 1993. These established the 'cultural exception' of the cinema, however, offering some measure of protection from the feared flooding of the French market with US products. More and more is at stake in analysing the relation between the American thriller and its French counterpart. Taking my cue from Godard, I will analyse this as a love story of desire and betrayal.

2. *A bout de souffle*

Perhaps the film which best articulates France's relation to *film noir* and best anticipates the developing relationship between French and US cinema is Jean-Luc Godard's *A bout de souffle* (1959).

Dedicated to Monogram Pictures, makers of American B movies, *A bout de souffle* is located from its start in a transatlantic exchange which is incorporated literally in the love affair (*histoire*) between Michel Poiccard (Jean-Paul Belmondo), a French petty gangster, and Patricia Franchini (Jean Seberg), an American student in Paris. This love affair is ambivalent, as is the film's relation to American cinema and *film noir* in particular.

As Jean-Pierre Jeancolas (1985) writes, '*A bout de souffle* est aussi un polar, filmé autrement' (is also a thriller filmed differently, p. 93). Michel commits a senseless crime near the start of *A bout de souffle* where he shoots a policeman on a motorbike by the side of the road. He is situated at this moment as a criminal, yet this role and the possible condemnation of Michel remain contingent throughout the film. The crime, aptly, is meaningless. Like Camus's Meursault, Michel has been shooting into the sun, shooting at random. The shooting of the policeman becomes a chance happening – ultimately determining his fate – which has no meaning for him. Michel is quickly marked as the victim of his own crime as he is seen in a characteristic longshot running away across the fields. Godard makes Michel the film's moving target. He is all too literally the agent of the film's action. He marks its pace. As the viewer, following the positioning of the camera, tracks him from a distance, we are reminded of the proximity between the role of the spectator and the role of the detective.

The film follows Michel until its final visual encounter with his face lying dead on the paving stones of the Paris street. Michel is the object of the camera's fascination, the ironic trigger of emotional and psychological identification, yet source too of crime, duplicity and deception. His progress through the film is, given its subject (a manhunt), surprisingly leisurely. Godard flouts conventions of structure and pace bringing at times a laziness to the film, a playfulness, which is abruptly undercut by moments of paranoia and sudden fear.

A bout de souffle maps its manhunt through the streets of Paris. The city has been a key location in *film noir*. Godard makes Paris a concrete twin of the American metropolis, marking here his affili-

ation with other *nouvelle vague* films which chart a spatial love story with the city of light (as we shall see further in chapter 7). The city in *film noir* is frequently a dark brooding space of deathly façades, falling rain and lamplit streets. Ironically Godard offers us the negative of this image in *A bout de souffle*, filming Paris in daylight for the most part and in sunlight in particular. He uses shots which establish his filmic city as a real geographical space: the Champs Elysées where Patricia sells her *New York Herald Tribune*, Notre Dame viewed from a passing car, the Arc de Triomphe and the Tour Eiffel. The visual evidence further affiliates Godard with the *nouvelle vague*. Technical developments, in particular the creation of a light moveable camera, offer new possibilities of location shooting. Where the early celebrated films of Paris such as Marcel Carné's *Hôtel du Nord* (1938) or *Les Enfants du paradis* (1943-5) use artificial sets evoking the Parisian locations (the Grands Boulevards, the Canal St Martin) they immortalise, both Godard and Truffaut revel in their early films in the possibility of filming in the street, in natural light. *A bout de souffle* is marked in particular by the work of Raoul Coutard, one of the most celebrated cinematographers of his generation. Coutard's work with a moving camera, in the scenes in the Champs Elysées for example, allows the film to capture the natural movement and vagaries of conversation between Michel and Patricia.

While its visual marking of the city as space of light and chance may seem the obverse of *film noir*, Godard manages no less to create Paris as a location of the underground, of paranoia, of the externalisation of psychic spaces, as the city found in *film noir*. Effectively Godard deconstructs the difference between dark and light, between internal and external, exploiting the possibility of opposition for opposition's sake. Much the same might be said of the film's moral codes where, by its ending *A bout de souffle* has rendered the difference between good and bad, between criminal and victim entirely indeterminate.

In exploring the city as space of paranoia, Godard works explicitly to question the means, images and words, by which cinema creates meaning. As the forces of the law close in around Michel

he finds his own identity, fate and criminality projected in the city around him. This is found overtly in the series of images from *France Soir* which punctuate the film. Michel avidly reads the newspaper to read his own history as *fait divers*. He reads in a headline that the 'meurtrier' has been identified. Godard then encourages the viewer to take part in, and to ridicule, this work of identification. We are given the identikit description of Michel – 'Michel Poiccard, 1m79, cheveux châtains, ancien steward d'Air France' (Michel Poiccard, 1m79, brown hair, former steward with Air France) – as the police come hotly in his pursuit in the aptly named Agence Inter-Américana. This is followed by his photo in the paper and a headline describing him in capitals as 'INSAISISSABLE' (translated in the subtitles as 'no trace of the highway killer'). Finally the viewer is treated to an image of a neon newsreel emblazoned on the buildings above Paris: 'PARIS: MICHEL POICCARD ARRESTATION IMMINENTE' (the net tightens around Michel Poiccard). Godard offers so many clues to the viewer, anticipating the action of the film, yet also concretising and reflecting Michel's fear, his paranoia, and his inability to escape filmic convention as much as his own destiny.

Michel's fear becomes at certain points part of the very rhythm of the film. T. Jefferson Kline comments on the film's 'highly nervous style' and this is evidenced in the very edginess created by the use of jump cuts. The film is marked too by remarkable changes of pace and by insistent high speed jazz music which again echoes Michel's febrile yet nonchalant progress through his drama.

The ways in which Michel finds his destiny projected around him could be read as so many delusions of reference where the urban landscape becomes a personal and psychotic space. Yet Godard seems to show that this paranoia, this overt referentiality, is an inherent property of (his) cinema. We are reminded of the ways in which Michel as character is a cinematic construct. He is fascinated, as has frequently been remarked, by the image of Humphrey Bogart. Godard cuts between close-up images of Belmondo and film stills of Bogart from *The Harder They Fall* (1956) which is playing in a cinema of the Paris of the film. Michel

is seen to imitate Bogart's gestures, just as Patricia says that she wishes her name were Ingrid (Bergman). *A bout de souffle* is saturated with literal and intertextual cinephile references, both French and American: a young girl is seen selling *Cahiers du cinéma*, *Hiroshima mon amour* is playing at one cinema, *Westbound* (1959) at another. The cinema itself is marked as space at once of paranoia and escape, where Patricia will give the detectives who are following her the slip by going into a cinema and exiting through the ladies room window. She and Michel will then take refuge in the cinema where *Westbound* is playing, before escaping again into the night.

Cinema, for Godard, is a location of escapism, of *amour fou*, yet equally it is entrapped in its own set of conventions. These are conventions which he tests and changes but which he does not, in this film at least, yet abandon. Michel has told Patricia complacently, in one of the most resonant and bleakly poetic lines of dialogue in the film: 'Les dénonciateurs dénoncent. Les cambrioleurs cambriolent. Les assassins assassinent. Les amoureux s'aiment' (Informers inform. Burglars burgle. Killers kill. Lovers love each other). This defines role play in genre cinema. In *A bout de souffle* we are given the illusion that the film will abandon these roles and that identity itself will become indeterminate. This is witnessed in the changing gender roles of Patricia and Michel. At times their roles are distinct, if artificial, where Michel wears his trilby hat and dark glasses and Patricia wears her starched Dior frock and little handbag. Yet in the poignant exploration of Michel's imitation of Bogart, in the fetishisation of Patricia's *gamine* haircut and profile, in the cutting between images of the lovers in the long bedroom scene, *A bout de souffle* seems to render sexual difference at once theatrical and indifferent.

However far she escapes her role as sexualised heroine, and passive object of desire at certain points, though, Patricia still falls victim to the coded behaviour of women in *film noir* by the end of the film. As we remember 'les dénonciateurs dénoncent' so the femme fatale remains fatal for the man who desires her. However much she differs from her counterparts in American cinema – Rita

Hayworth, or Barbara Stanwyck for example – Seberg remains true to her role. Patricia will choose to betray Michel, to give him up to the police, and to make her own bid for freedom.

Michel accepts her betrayal with equanimity, saying: 'la petite Américaine m'a dénoncé' (the little American has informed on me). Patricia is suddenly reduced to her race: she is instantly objectified as the alien other. Yet this rejection is at odds with the fascination with that other the film has explored in both form (the questioning of US *film noir* conventions) and content (the love affair between Michel and Patricia).

A bout de souffle remains ambivalent about the influence of American cinema in France. That this should be represented by a love story, an *amour fou*, fired by a love of difference, yet marred by fear of betrayal, seems ultimately apt. Godard takes an American genre and subverts it from within (as he will do with the American musical in *Une Femme est une femme*, 1961). His films imitate US cinema, yet remind us of their imitative and allusive status. In this way they succeed in doing more than rival American film, creating an idiom which is at once heavily overdetermined and highly original.

3. A Girl and a Gun

Besson's *Nikita* (1990) is typical of the genre transgression of the postmodern *polar*. Susan Hayward argues that though the film is supposedly of the *polar* tradition, it should most properly be considered in the context of other postmodern explorations of gender and sexuality, such as *37°2 le matin*. Hayward is wary of *Nikita* as a result of its images of women as sexually armed and dangerous beings. While this caution seems important, I will argue here that *Nikita* achieves a transformation of the *polar* and a transgression of gender stereotypes precisely through its attention to the female killer. The femme fatale of the *film noir* has metamorphosed to become a girl with a gun. We see this metamorphosis cinematically where Nikita (Anne Parillaud) is given 'lessons' in femininity by none other than Jeanne Moreau, archetypal actress of the *nouvelle*

vague and *fatale* star of such French *noir* thrillers as Louis Malle's *L'Ascenseur pour l'échafaud* (1957). Besson demonstrates his own debts as *cinéaste*, but seems to suggest that, like Nikita, French *film noir* will through his art and artifice be reborn in radically new forms.

The cultural theorist Slavoj Žižek has argued that in order to be kept alive *film noir* of the 1980s and 1990s needs an influx of fresh blood from other sources. This comes in film in the combination with other genres. In this respect *Nikita* is an ideal example and difficult to pinpoint generically. Ostensibly a *polar*, this is on the surface a crime film which stages high speed urban crimes carried out by both a criminal underclass and a sinister (French) police state. The film is true to the moral ambiguity of *film noir*, or rather it is entirely amoral in its representation of crime and death. *Nikita* demonstrates the waning of affect (or loss of feeling and emotion) which is associated with postmodern films: the multiple deaths of the film become so many exhilarating visual effects – where the viewer is intoxicated by the precision and efficiency of Nikita's work as undercover assassin. True to *noir* too is the urban setting. Besson shows two sides of Paris with stately buildings and a sumptuous restaurant, backed and substantiated by a lightless underworld of tunnels, kitchens, back alleys, rain sodden streets and bleak prison cells. Through mise-en-scène and visual echoes Besson creates a residual similarity between all these underworld (and underground) spaces in which the individual is incarcerated. These are the regulatory spaces of the state regime he explores, as they are the classic locations of *film noir* and its representation in the *cinéma du look*.

There is a marked similarity between the de-realised city of *Nikita* and the neon-lit, overcast and rainy metropolis which recurs in other postmodern revisions of *film noir*. Think for example of the urban spaces of Ridley Scott's *Blade Runner* (1982). *Blade Runner* is cited by Žižek as one of those films in which *film noir* vampirically draws blood from another genre. Here science fiction. This itself has relevance to *Nikita*, since Besson, like Scott, makes use of genre film similarly to question human identity, and the pos-

sibility of individual agency within a personal history. *Blade Runner* strips away humanity altogether in its exploration of the replicant (an automaton or robot in a convincing human form), leaving the viewer arguably with the recognition that even Deckard (Harrison Ford) is a replicant too, if unwittingly, and that human identity as we know it is an artificial construct. Besson does not go so far and creates a sexual rather than science fiction (reminiscent of the *amour fou* we looked at in the previous chapter). Yet still his imaging of identity is highly subversive.

Nikita is outwardly a thriller. Inwardly it explores memory, identity and female sexuality. From the start Nikita as protagonist is shown to be incomplete in some way. She seems drugged when she first appears, is plugged in to a walkman (in an image which recurs later) and apparently numb in the face of the robbery and shoot out in which she is involved. Her action in shooting the *flic* (cop) and her later proficiency in violent acts are seen to be natural, untutored and uncontrolled. Nikita begins almost as a blank slate. This impression is enhanced in the film where she is put to sleep with a heavy injection. This, together with the tearful love-making scene at the film's end, is one of the few moments where Besson allows pathos to break through the surface of the film. As she is put to sleep, Nikita cries for her mother. She is infantilised and this is confirmed visually as she is seen frequently dishevelled and part undressed, like a child in a painting by Egon Schiele. Nikita is the archetypal *femme-enfant* of Surrealism as Besson appears to allude to Breton's *Nadja* and even perhaps to Hans Bellmer's disturbing photographs of women and/as dolls. Indeed Nikita's movements, slightly uncoordinated, frequently resemble those of a marionette.

After she has been drugged and put to sleep, she awakes to find herself reinvented as a pawn of the state. Bob, who becomes later, and aptly 'l'oncle Bob', narrates her new life history for her. She has taken an overdose and died. He shows her photographs of her funeral and gives her directions to the plot where she is, or will be, buried. He becomes by this the master of her destiny. The film marks a split where personal history and lived identity divide. Nikita, like the replicants in *Blade Runner*, is suddenly an entirely

contingent being who is severed from her past and reinvented, mind and body. This reinvention takes the form of intense physical training in the paranoid fantasy academy which Besson has imagined in detail. Her body becomes a (killing) machine. She must further be imprinted with a gender identity to become a 'legible' and effective individual. This is where Jeanne Moreau comes in. For Besson femininity is tied entirely to artifice. Gender is seen to be entirely a construct in terms that fit very well with the theories of Simone de Beauvoir and Judith Butler.

Besson works with a tradition in French art and literature which has been marked from the nineteenth century onwards by an obsession with the myth of Pygmalion and Galatea from Ovid's *Metamorphoses*. This is found in its most popular form in film in *My Fair Lady* (1964) and *Pretty Woman* (1990), but is also witnessed in art cinema productions such as Rivette's leisurely and luscious *La Belle Noiseuse* (1991), a film about a painter's obsession with painting a woman (Emmanuelle Béart), inspired by a Balzac short story. Transposed though the myth may be, its dictates determine the relation between Nikita and Bob where she becomes his puppet, his pupil, and his model. His role as creator is eerily substantiated further when he later comes to dinner with Nikita (now named 'Marie' as a disguise) and her boyfriend Marco. Marco is intensely curious about Marie's past and questions 'l'Oncle Bob' about her childhood. After a pause, and suspense for the viewer, Bob offers a memory of Marie as a little girl of eight, authenticating each detail with precision. Her long hair with its golden tints, tied in a plait, her white dresses, her cousin Caroline. Bob creates an implausibly Impressionist childhood, with hints of Renoir, both painter and director. He demonstrates that memories can be construed too, that an individual needs a personal history to exist and to be known and recognised, but that that personal history may be nothing more than a false construction, a false flashback inserted in the continuum of a film.

When Nikita has achieved perfection at the 'academy' she is allowed outside after her initiative has been brutally tested in a restaurant shoot out. She survives, ingeniously, and her perfect

adoption of a new identity is marked metaphorically in a birthing scene where she falls down a rubbish shoot, her curled body visually reminiscent of a foetus. She is born fully grown and takes up an artificial place in society, gradually developing a life for herself as she decorates her apartment and boldly chooses and seduces a boyfriend, Marco, played by Jean-Hugues Anglade. (This seems a nod to Beineix who uses the actor to play Zorg in *37°2 le matin*.) Marie is shown to be predatory and deceptive. She calls the shots in the relationship and in its recesses she acts as Joséphine, a special agent trained to kill. In the relationship between Marie and Marco, Besson seems to envisage a certain transformation of gender stereotype. It is as if the recognition of femininity as construct, as artificial identity, allows Marie a new gender mobility and, ironically, a new freedom to play different roles in her personal life.

The substitution of Marco for Bob as her major interlocutor allows the film to function in a different register as it comes closer to psychological realism. This is the register in which Marco offers a different reading of Marie's relation to her past. He is carefully aware of the way she appears to have severed any links with a personal history or past identity. For Marco, she is a victim of trauma and he wonders what it is which traumatises her to such an extent that she has cut off completely from all that went before. The film works to signify in these terms too, claiming the psychological drama of trauma as its domain as much as the science fiction *noir* field of a film such as *Blade Runner*. This more intimate and moving thread is worked out further through surprising debts to *Nikita* in Kieślowski's *Trois couleurs: bleu* (1993). Kieślowski appears to refer to *Nikita* not merely in the use of colour filters and lavish cinematography, but more closely in the proximity between the scene where Nikita first awakens in the white clinic after she has been stripped of her past, and the scene where Julie, played by Juliette Binoche, awakens in a white hospital room to find that her husband and daughter have died in the car crash which she survives. Both Besson and Kieślowski seem to show that the postmodern protagonist is stripped of personal history by state intervention or

personal (and physical) trauma. Identity becomes a new invention.

This is what is liberating and exhilarating about *Nikita* and its end in particular. Besson appears to have produced a new image of woman as action heroine (though how radical this move is critics such as Hayward evidently dispute). He creates a hybrid image of force and frailty as we see Parillaud in pearls and cocktail dress, armed with a gun. Guns are fetish objects throughout the film. There is arguably pleasure to be gained from the image of Parillaud as *femme phallique* (a psychoanalytic term for a woman with a penis, associated with the mother who is supposedly all-powerful before the child realises her 'castrated' status). Parillaud is seen like this as she wields power and crosses gender boundaries. The image spawns its own series of replicants in the action movies of the 1990s. But more than this, coming dangerously close to sexist cliché, Besson seeks to define Nikita, and women by extension, as that which cannot be defined. Like Nadja, or Duras's heroine Lol V. Stein, Nikita, even incarcerated, cannot be confined or defined. She escapes at the end of the film (unlike her literary counterparts). She is finally absent from the frame of the tracking camera. The film is left to focus on the homosocial bond created between Marco and Bob as they acknowledge between them how they will miss Nikita.

Nikita has been missing, one way or another, from the start of the film. It is apt that she is missed too at its end. The female protagonist, after an efficient march through the paces of the thriller/action movie, finally escapes its genre confines and outstrips its limits. Nikita's freedom is a move forwards from Betty's death in *37°2 le matin* and a new bid not merely for female independence but for freedom from gender or genre definition. Identity in *Nikita* is acknowledged as artificial and, in Judith Butler's terms, as the product of compulsory and repeated performance. Nikita chooses finally to navigate her own identity beyond the voyeuristic gaze of the camera and spectators. Like Truman in Peter Weir's *The Truman Show* (1998), she effectively moves out of the frame.

Through *Nikita* Besson looks in new terms at the thriller as a

place for the reconstruction and redefinition of identity. He allows his heroine to follow a *ligne de fuite* which leaves the film finally as an anarchic work which looks outwards beyond genre boundaries. Yet *Nikita* is aptly inserted too into the *auteur* corpus of Besson's works. Here indeed Besson attempts to renegotiate the relation between French and American filmmaking in his own career. *Nikita* follows *Le Grand Bleu* (1988), his hugely successful foray into international production and the height of his ravishing play with colour and light. *Nikita* adopts the very colour scheme of *Le Grand Bleu* at certain points, yet the later film works to establish Besson's place all the more firmly in the French *cinéma du look* which he had proved previously with the ironically titled *Subway* (1985).

The thriller has been very much a test genre for French *auteurs* where they mark the genre film with their own auteurist signature. This can be witnessed in Pialat's *Police* (1985), Tavernier's *L.627* (1992) or Téchiné's recent *Les Voleurs* (1996). Besson clearly makes a French thriller in *Nikita* with its Paris setting, its concern with identity, sexuality and desire. Yet rather than unifying his auteurist identity in national terms, the film again provides a springboard for hybrid, international production. In *Nikita* the small part of Victor *le nettoyeur* is played with panache by Jean Reno who will acquire further fame starring as the eponymous hero in Besson's English-language thriller *Léon* (1994). The role of the *nettoyeur* is itself reprised in Harvey Keitel's part in *Pulp Fiction*. *Léon* is again a specifically Gallic revision of the thriller. The film places at its centre the platonic relationship between Léon and a twelve-year old girl played by Natalie Portman. Although the film avoids the pre-adolescent eroticism of Adrian Lyne's *Lolita* (1997), the fairy tale terms of *Léon* are far from unambiguous. It follows the sexualisation of the child, through the focus of the camera and the gaze on her body, which is already familiar in French culture in the images of Balthus or the films of Louis Malle. *Léon* is unsettling in its use and idealistic abuse of child/adult relations. The series of questions it raises are very familiar in French culture. It might be argued, in Besson's defence, that in *Léon* all he does is literalise the infantilisation of the heroine we find already explored in *Nikita*.

Besson's sexual politics are highly questionable, yet his films, like Godard's, offer a space where genre can be used to question gender and sexuality. Thrillers in France are by no means exclusively dominated by issues of identity and desire. But in their response to and incorporation of the sexual role play of American *film noir*, the films under discussion here offer a new and modified vision of the polarised personal histories of the conventional *polar*. More generally in France, the thriller has been a vehicle for testing the strength of the filmmaker, his or her personal obsessions and his or her relation to cinema history. For Godard and for Besson, this personal history privileges ambiguity, transformation and the flight from fixity. Accordingly their films remain forcefully hybrid, feeding on American cinema in order to define the French thriller in startling new terms.

Selected Reading

Joan Copjek, *Shades of Noir: A Reader* (London, 1993). This excellent anthology includes a chapter by Slavoj Žižek, 'The Thing that Thinks: The Kantian Background of the Noir Subject' (pp. 199-266).

Jill Forbes, 'Hollywood-France: America as Influence and Intertext' in *The Cinema in France after the New Wave* (London, 1992), pp. 47-75. A revelatory analysis of relations between French and US cinema, with particular reference to the thriller.

Susan Hayward, *Luc Besson* (Manchester, 1998). A good introduction to Besson.

E. Ann Kaplan, *Women in Film Noir* (London, 1978). A feminist study of American *film noir* which offers an interesting background to understanding the role of the femme fatale.

Olivier Philippe, *Le Film policier français contemporain* (Paris, 1996). A comprehensive study of the *polar* (with illustrations).

Films

A bout de souffle. Cahiers du cinéma, no. 106 (April 1960), pp. 25-36; *Monthly Film Bulletin*, no. 330 (July 1961), p. 90.

Nikita: Cahiers du cinéma, no. 430 (April 1990), p. 74; *Monthly Film Bulletin*, no. 682 (November 1990), pp. 331-332.

5

Histories I: Trauma

1. Film and Testimony

In the previous chapter brief mention was made of the question of cinema, trauma and amnesia. These are issues which surface all the more urgently in French cinema of the last fifty years which attempts to represent or reckon with the history of this period, and in particular with the post-war legacy. This will be the major subject of this current chapter. Where in French history the war in Indochina, the Algerian war and the events of May 1968 (amongst many other events) may be seen to have held particular importance, it is noticeable that French cinema has, with a few exceptions, returned time and again to the Second World War and not to more recent events in its search to question the representation of history, mass events and massive trauma. This may later prove a generational phenomenon, but what is telling perhaps is the attempt within French cinema of the last several generations to make sense of the position of France and the French in the global context of the Second World War. French cinema is nourished in particular by this interchange between a national history and international events, and the broader context offered for the exploration of representability as such. This issue of representability takes us directly to testimony itself.

One of the most important works on history and testimony to date is Shoshana Felman and Dori Laub's *Testimony: Crises of Witnessing in Literature, Psychoanalysis and History*. It is worth quoting Felman at length. She explains: 'Oftentimes, contemporary works of art use testimony both as the subject of their drama

and as the medium of their literal transmission. Films like *Shoah* by Claude Lanzmann, *The Sorrow and the Pity* by Marcel Ophuls, or *Hiroshima mon amour* by Marguerite Duras and Alain Resnais, instruct us in the ways in which testimony has become a crucial mode of our own relation to the traumas of contemporary history: the Second World War, the Holocaust, the Nuclear bomb, and other war atrocities. As a relation to events, testimony seems to be composed of bits and pieces of a memory that has been over-whelmed by occurrences that have not settled into understanding or remembrance, acts that cannot be construed as knowledge nor assimilated into full cognition, events in excess of our frames of reference' (p. 5).

Felman covers many points here. She refers to both the form and the content of films which contend with contemporary history and trauma. She suggests that testimony, in other words the act of bearing witness or offering a first person account authenticated by personal experience, has become the most important means of access to contemporary history. The general or 'objective' account does not adequately represent mass events in this argument: his-tory is recognised as a fabric of multiple personal histories, directed by the voice testifying to the events which an individual has witnessed, and the pain she or he has known. Such a means of transmission of knowledge is at once essentially reliable, yet fis-sured by the faultlines of trauma itself, by the ways in which massive trauma annihilates the means of recording events in the individual psyche. An act of reconstruction and narration is neces-sary both for the events to be remembered and, arguably, for the individual him or herself to attempt to come to terms with the trauma and experiences which have scored him or her from within. Contemporary film has taken this painful process of wit-nessing as its subject.

This subject works to change the form of the 'historical' film. Here a distinction should be made between those films which con-tend with the possibility cinema offers of fixing and representing historical events, and those which seek with nostalgia and hindsight to reconstruct a particular period. Of course some films, such as

Louis Malle's *Au revoir les enfants* (1987), which I shall look at below, partially collapse this distinction. Nevertheless those films which more overtly privilege nostalgia in their evocation of historical period will be dealt with in the following chapter. In films which take history and trauma as their subject, directors frequently have recourse to a form of collage where representation takes place through the juxtaposition of a series of images, accounts and perspectives in such a way that a totalising account is refused, and gaps are perceived between separate histories. This allows a more interrogative approach to the events represented, and reflects as well the doubts and fissures which open in the traumatised psyche. As well as using collage effects, directors work too to question the relation between documentary and feature film. Film as a photographic medium can supposedly give us unmediated access to 'real' events and a permanent record of the past. Yet, ironically, directors work to present the inaccessibility of the past, showing up the ways in which representation, however faithful, is always coded and construed in such a way as to offer a 'message' or impression to be experienced by the viewer. The most authentic films, in these terms, are those which are most self-conscious about their own aesthetic effects.

In the passage cited from *Testimony*, Felman makes mention of three of the most groundbreaking works which explore the possibility of film as commemorative medium. Claude Lanzmann's *Shoah* (1985) is in two parts and lasts over nine hours. In the context of films which attempt to present the Holocaust through cinematic means such as Steven Spielberg's *Schindler's List* (1993) and Roberto Benigni's *Life is Beautiful* (1998), *Shoah* remains a monolith and touchstone of ethical representation. Indeed, Lanzmann refuses representation in the conventional sense, never attempting to produce or review a filmic image of past events, but depending instead, and insistently, on spoken testimony in the present. The film takes the form of a protracted series of interviews where Lanzmann himself becomes the organising principle of the narrative. As viewers we witness his encounter with Jewish survivors of the Holocaust, with inhabitants of the Polish villages where the atrocities whose victims he commemorates took place, and with

(former) Nazis. For Lanzmann, we cannot know the events in the past, but it is an ethical necessity to attempt to know the events in the present, to remember them in the face of their horror and impossibility. His film becomes a pained encounter where spectatorship takes on a new force and savagery. As spectators we are drawn in by the film to become the interlocutors of the individuals who testify. We are the recipients of their testimonies, but we are drawn to recognise our own inadequacy as listeners and the impossibility yet necessity of this project as a whole.

Lanzmann strives on every level, with remarkable success, to achieve authenticity and a truth of representation. The period in which the film is made (from the 1970s to the mid 1980s) is crucial where the film depends on the literal lived experiences of the survivors and perpetrators it captures. Despite its sheer authenticity, *Shoah* is not without artistic effects. These are found in a peculiar lyricism. Simone de Beauvoir writes in her preface to the published screenplay: 'Le grand art de Claude Lanzmann est de faire parler les lieux, de les ressusciter à travers les voix, et, par-delà les mots, d'exprimer l'indicible par les visages' (the greatness of Claude Lanzmann's art is in making places speak, in reviving them through voices and, over and above words, conveying the unspeakable through people's expressions, p. iii, translation from the published edition).

Place is highly important in *Shoah* where Lanzmann literally revisits the sites of the Holocaust. The film opens at Chelmno, which was the site of the first extermination of the Jews in Poland. Lanzmann films the verdant countryside and the extraordinary peace which surrounds the place of horror. We see a middle-aged man in a boat which is steered by an elderly boatman along the course of the dark river Ner. The image signifies a crossing over. The river recalls for a moment the river Styx which mortals cross to reach the Underworld in Greek mythology. The boatman resembles Charon. The very tones of the shot are reminiscent of Joachim Patinir's painting *The Crossing of the Styx* in the Prado. Lanzmann illustrates visually the path we will take to enter his film and the Underworld which will be his subject.

The image takes on further resonance as we discover that the man in the boat was a child survivor of the camp at Chelmno. Simon Srebnik witnessed his father being killed in the ghetto at Lodz; his mother was gassed at Chelmno. He survived in the camp because he was physically strong and quick, and because he had a beautiful voice. He would be taken by SS guards in a boat on the river Ner and he would be made to sing Polish folksongs to them. With due pathos, as viewers of *Shoah*, we hear Srebnik sing again. The song becomes a litany for his lost past, of extraordinary melancholy and beauty. The very words of the song we hear evoke memory traces: 'Une petite maison blanche / reste dans ma mémoire. / De cette maison / chaque nuit je rêve' (A little white house / lingers in my memory. / Of that little white house / I dream each night) (p. 4). The middle-aged Srebnik evokes the presence, and loss, of his thirteen year old self as Lanzmann's film seems to meditate on the possibility of calling up the past as illusion within the very frame of the present image. Resuscitation is also, eerily, an integral part of Srebnik's personal history. The concentration camp offers its own near death experience. This is only substantiated by the extraordinary fact of Srebnik's own survival. In the night of 18 January 1945, two days before the arrival of Soviet troops, the Nazis killed the last Jews in Chelmno, shooting them in the neck. Srebnik was one of these Jews. But the bullet missed his vital brain centres. He came back to consciousness, was rescued by a Polish peasant and saved by a Red Army doctor. A few months later he left for Tel Aviv, to be discovered later by Lanzmann in Israel.

Srebnik's bodily presence in *Shoah*, and his voice singing, serve as visceral reminders of the past as event, of the fragility of the individual, and of the (im)possibility of survival. Yet the words which Srebnik speaks as he is interviewed by Lanzmann work to remind the viewer of the incommensurability of the past and the present, and of the impossibility of representing the Holocaust which Lanzmann will nevertheless take as his subject. Srebnik says, indeed: 'On ne peut pas raconter ça. Personne ne peut se représenter ce qui s'est passé ici. Impossible. Et personne ne peut

comprendre cela. Et moi-même, aujourd'hui ...' (No one can describe it. No one can recreate what happened here. Impossible? And no one can understand it. Even I, here, now ...) (p. 6). Srebnik reminds us of the impossibility of placing this public and personal trauma in narrative. His words take us back abruptly to the place: we are reminded that what we see here, in all its tranquillity, is the site of horror. The brute evidence of place cannot adequately be matched in narrative. Srebnik suggests that any narrative, even his own, that of the literal survivor, will be faulty or inadequate. This is the frame of reference in which Lanzmann places his film. He chooses to begin with a recognition of failure and impossibility, to which the film will return, despite its growing achievement as we watch and its capacity, through patience and humility, through repetition and insistence, to evoke a part or shadow of its subject.

Shoah stands alone in French filmmaking. In its importance, as much as in its range of languages and locations, it far outreaches the confines of national cinema. It is an act of memory work which attempts to commemorate a phenomenon which is unrepresentable and which is incomparable even with other war atrocities and acts of genocide. Nevertheless, its work with the filmic medium can be more readily compared with the general movement in French cinema to understand the relation between memory and filmic images. This is linked to an invocation of the capacity of cinema to evoke mental processes, their (mal)function and their temporal and mnemonic impressions. This leads us to the work of Alain Resnais, a director associated with the *nouvelle vague*, though not one of its core of critics and filmmakers. Resnais is evoked by Felman in *Testimony* but, unlike Lanzmann, not directly discussed. In directing *Hiroshima mon amour* (1959), Resnais opened a new space in the French cinematic imagination and offered a new set of relations between public and personal history.

2. *Hiroshima mon amour*

Alain Resnais first gained acclaim for his work as a documentary filmmaker in the 1950s. His documentaries on such diverse sub-

jects as African art, *Les Statues meurent aussi* (1950-3), or the Bibliothèque Nationale, *Toute la mémoire du monde* (1956), are marked by a certain formalism, slow tracking shots, an interest in spatial relations and in inanimate objects. Resnais marks his subject with his signature, demonstrating overtly the ways in which documentary can offer a subjective perspective. Throughout his work he has been interested in questions of time and memory: this is witnessed both in his documentaries and in his later feature films. Yet the question of memory is excavated most thoroughly in those of his films which take trauma as subject.

In 1955 Resnais made the documentary *Nuit et brouillard* which has been described as 'the first serious documentary on the concentration camps to reach a wide public' (Richard Raskin, 1987). The film, like *Shoah*, is itself a collage piece, making its audience question the relation between words and images, places and memories. Resnais uses a text written by Jean Cayrol, himself a survivor of Mauthausen. This is set against Resnais's own very distinctive images in colour and newsreel footage in black and white. Using both colour and black and white photography, Resnais appears to maintain a distinction between past and present. Yet rather than privileging the veracity or verisimilitude of one means of representation over another, the effect is rather to evoke two interlayered sets of images, both of which speak of horror, neither of which entirely traverse the impossibility of representation in which the subject is necessarily shrouded.

Resnais, like Lanzmann, recognises the importance of place to memory. The film opens in the present at Auschwitz with the words: 'Même un paysage tranquille ...' (even a quiet country scene). In slow tracking shots Resnais's camera takes us round what remains of Auschwitz. The commentary reminds us: 'Le sang a caillé, les bouches se sont tues, les blocks ne sont plus visités que par une caméra' (the blood is caked, the cries stilled, the camera now the only visitor). The work of the film will conversely be to contradict the burial of memory which seems to have taken place. The camera will serve precisely to reanimate the space and place of atrocity and call up the dead from their graves. This illusory res-

urrection will take place in part through the intercutting of past and present images, through montage effects which demonstrate Resnais's fidelity to Eisenstein (director of *The Battleship Potemkin* (1925), who emphasised the ways in which contrast between strongly different images creates meaning in film). In *Hiroshima mon amour*, black and white newsreel footage returns again and again in the film to disrupt and focus our perceptions. We are confronted, in due horror, with a photographic reality of spaces, places and people. Yet Resnais contends too with the risk that these images will become visual objects and lose their emotive power. The latter part of the film is dominated by images of the body in humiliation, agony and death. The images at once commemorate the horror they represent, yet simultaneously fix it, petrify it, hide it from view as they become so many excruciating abject patterns. *Nuit et brouillard* suggests that the true horror of the camps lies far beyond these images we can see.

In *Hiroshima mon amour* Resnais revisits some of the images of bodily horror of *Nuit et brouillard* and confronts all the more directly the very inadequacy of his (or any) medium for representing trauma, be it personal or historical. As Marguerite Duras writes in the published screenplay: 'Impossible de parler de HIROSHIMA. Tout ce qu'on peut faire c'est de parler de l'impossibilité de parler de HIROSHIMA' (Impossible to speak of Hiroshima. All one can do is speak about the impossibility of speaking of Hiroshima).

Hiroshima mon amour is effectively a double-authored film. After the success of *Nuit et brouillard* Resnais was commissioned to make a film about Hiroshima. He found, however, that to make another documentary would only be to repeat the images and the encounter with horror he had already explored in *Nuit et brouillard*. Seeking a different, yet related, emotional and aesthetic effect, he set about looking for a writer with whom to collaborate in the making of a feature film. One of the writers he considered was Françoise Sagan, but apparently she failed to turn up for a meeting with Resnais and his producers. Resnais had recently read Duras's novella *Moderato cantabile* which was a literary success in 1958. His

admiration for her text (which, like Resnais, she revisits in the script of *Hiroshima mon amour*) led directly to their working together. Duras produced a written script which exists as a work of art in its own right and provides the insistent voices which direct and emanate from Resnais's images. Voice and image in *Hiroshima mon amour* offer two levels of expression. At times the visual and vocal narrative coincide exactly; at times, with shock effect, they diverge, leading the spectator to question their interrelation and juxtaposed effects.

Hiroshima mon amour is, in every way, a film which questions the possibility of dialogue and interrelation. Not only is it the product of two separate artistic sensibilities, Resnais and Duras, it also works to counterpoint the voices and experiences of two individuals, a French woman and a Japanese man, in two locations, Nevers and Hiroshima, and two periods, France in 1944 and Japan thirteen years later. Conceiving the film, Resnais is faced with difficult ethical issues, relating not merely to mass trauma and representation, but also to the fact of the bombing of Hiroshima effectively being a crime of the allied forces. He approaches his subject matter tangentially, therefore, but with little reduction in its emotive or political force. Resnais interweaves a representation of the atrocity of the atomic bomb, with a personal history, that of the young French actress who has come to Hiroshima to act in a film about peace. Personal and public trauma are plotted together. For some critics, the film is seen to suggest that it is only through the experiences of an individual that we can come to understand trauma. I would argue, however, that the personal history of Nevers and the public history of Hiroshima work in parallel where Resnais and Duras show both the personal and the public to be irresolubly painful. As there is no effective representation of trauma in film, so there is no effective escape from lacerating life events beyond hollow rituals of mourning and the deadening power of 'l'oubli' (forgetting).

Hiroshima mon amour opens, famously, in denial. The first shots we see image two lovers making love. We do not see their faces, but only their limbs and torsos entwined. Race and even gender are

erased in these first moments. Accompanying these images is a dialogue of disembodied voices. A man speaks first, saying: 'Tu n'as *rien* vu à Hiroshima' (you have seen *nothing* at Hiroshima). A woman replies: 'J'ai *tout* vu. Tout' (I have seen *everything. Everything*). This dialogue and these images already deny an image which was first intended to start the film. In the screenplay we read that the film was to open with an image of the mushroom cloud. This, the most obvious image of the bombing of Hiroshima in the public imagination, is not seen directly in the film. Just as Hiroshima the city survives within its own annihilation, *Hiroshima mon amour* will exist in the denial of representation.

The first twenty minutes of the film offer us newsreel and reconstrued images of Hiroshima which on one level speak in their own awfulness. We see the city destroyed, the dead and the maimed, and painful, barely restorative medical operations. These are the public images of Hiroshima. Yet Renais shows that even these are fixed, false and approximate. These are images which appear as if from the mind's eye or consciousness of the French woman who knows Hiroshima only as a stranger. The images appear as her voice takes over in the opening dialogue and we see visual evidence that she has, supposedly, seen everything there is to see. Her words are insistently contradicted by the Japanese man, who says repeatedly that she has seen nothing. The flood of documentary style images is arrested as the man speaks. The film suggests that this trauma cannot be known, despite the effort to reckon with it. Interestingly, the man's own feelings and impressions of Hiroshima are almost absent from the film. The woman asks him, foolishly, at one point whether he was at Hiroshima when the bomb fell and he replies that of course he was not. We are reminded that the bombing of Hiroshima was an event which annihilated its own witnesses. The Japanese man is a survivor in some sense since he was elsewhere in Japan at the time. Leaving his narrative blank may appear to allow the French woman and her history to dominate the narrative. Yet surely what is not represented is all the more powerful than what appears in words and images. The man's trauma remains an absent centre in the film.

His silence and his unknowability allow him more effectively to become an agent in the woman's re-narration of her past. He is the film's moral centre, its point of authentification.

The first part of the film is relentless and exhausting where as spectators we face images of horror and their very inadequacy. The pace and affect of the film changes, however, as we move into a series of marvellous tracking shots through the streets of the newly-built Hiroshima. The moving camera gathers momentum, exhilarating the viewer. The voice-over is now the lone inner monologue of the woman. As we ride through this exterior space of the city we find ourselves entirely within the inner space of her consciousness where the imbrication of love and death is located. Her voice distressingly mingles pain and pleasure: 'Tu me tues. Tu me fais du bien ... Dévore-moi. Déforme-moi jusqu'à la laideur' (You kill me. You give me pleasure ... Devour me. Deform me until I am hideous). The title *Hiroshima mon amour* marks the film out as a film about love and death, the Freudian *Eros* and *Thanatos*. The opening shots establish this subject. The images we see of bodies making love, their skin glistening with sweat, are intercut with images of morbid bodies covered in lethal, glistening ash. The film tells the history of two entwined love affairs (*histoires d'amour*), in each of which love and death become linked.

In Hiroshima, the French woman has a casual encounter with the Japanese man. Their night of passion is illicit (both are married) and contingent. In this forbidden space, outside time and in the arms of an unknown lover, the French woman comes to confront and voice a trauma from her past. This is the trauma of Nevers, of 1944, which will intrude upon the images of Hiroshima in the present in the film. The woman speaks of her love affair in Occupied France with a German soldier. We see long shots of the couple in the countryside finding illicit refuge in barns and outhouses. The German lover is shot by the Resistance, however. The French woman's last embrace is with his dying body. She lies with him until morning when his body is cold. In this embrace love and death are linked. Her loss is supplemented by the moral outrage of the town dwellers. Her hair is shorn and she is shut in her parents'

cellar, a space which proves both incarceration and protection. When her hair has grown back and time has passed, her parents set her free to cycle to Paris through the night. When she arrives in Paris, the name Hiroshima is in all the papers. Her escape coincides with the massive trauma of the atomic bomb. In this temporal and personal coincidence we find the relevance of Hiroshima to Nevers, and the reason for the location in Japan as stage for the woman's encounter with her past.

The encounter in Hiroshima allows a means of retelling, and importantly reliving the forbidden love affair. For Duras, as so frequently in her fiction, the erotic becomes a mode of access to both knowledge and forgetting. The woman in *Hiroshima mon amour*, is caught, perpetually it seems, between recalling her love affair as she speaks with the Japanese man, and denying and displacing it, betraying her traumatised memory as she finds new pleasure in forbidden passion. The Japanese man serves visually and vocally to replace the German lover. Resnais cuts between an image of the Japanese man lying asleep and a similar image of the German man lying dead. We are given access to the image patterns and memory triggers of the woman's consciousness. The man himself is seen to encourage this confusion of identity as he continually leads the woman into evocation of her past. Their dialogue takes on the form of a psychoanalytic session and, playing the part of analyst, he encourages the woman to identify him as her lost love object and to transfer onto him the passion and fear of the past. If this relation is ethical, its aim is healing. We can never be sure whether this is achieved, however, whether the Japanese man exploits the woman for his own ends, whether indeed Resnais and Duras have faith in the talking cure of psychoanalysis.

Hiroshima mon amour privileges uncertainty, ambivalence and incommensurability. This is its challenge to the viewer and its ethical and aesthetic innovation. The film can be confusing to watch at first, since it privileges a collage form which cuts continually between present and past. Gradually, as we watch, the images of the film take on more meaning, yet the jagged, discordant effect should remain if the shock of the film is to be felt most strongly.

Memory is an intrusion; thoughts and images are shown to be disruptive. This is particularly apt in the presentation of a traumatised psyche. Resnais allows form and content again to reflect one another.

The philosopher and film theorist Gilles Deleuze has written powerfully about the film in a volume on cinema and time entitled *Cinéma 2: L'Image-temps*. For Deleuze, Resnais's achievement is in making a film which evokes the process of memory and the mind in mnemonic function. Perhaps the only other film made in France which equals his achievement is Chris Marker's extraordinary *La Jetée* (1962) (which inspired Terry Gilliam's *Twelve Monkeys*, 1995). Deleuze places Resnais on a parallel with a writer such as Proust in his representation of memory as subjective and distorting. Resnais pursues his interest in memory and inaccessibility in his next film *L'Année dernière à Marienbad* (1961), an extraordinary film of visual exactitude and beauty which becomes almost lost in its own games of doubt and denial.

In *Hiroshima mon amour* Resnais shows how difficult it is to have access even to one's own personal history. This personal history is necessarily renegotiated with relation to another individual and in another location. The past is seen both to be inaccessible, yet disturbingly and uncontrollably present in the woman's consciousness. In these vicissitudes of memory, Resnais leads us to think about public history and the impossibility of representation. This dual import guarantees the pathos and profundity of the film, explaining why it has remained one of the most memorable and important French films of the past fifty years.

3. The Legacy of Trauma

Shoah and *Hiroshima mon amour* already introduce the issue of temporal distance from the events of the Second World War. This is distinctive in cinematic representations of history. The films I have examined in this chapter so far make the past present, while questioning representation and survival. In this final section I want to look at one further film which works to separate the present more

firmly from the past, while acknowledging the difficulty of this task.

This film is Louis Malle's *Au revoir les enfants* (1987), a significant film in Malle's own history as French filmmaker. Malle is one of the group of directors associated with the *nouvelle vague*. He is described by René Prédal as 'un auteur indépendant à l'époque de la *nouvelle vague*' (an independent *auteur* of the *nouvelle vague* period). His first two feature films, the *noir L'Ascenseur pour l'échafaud* (1957) and *Les Amants* (1958) starred the wonderful *nouvelle vague* heroine Jeanne Moreau. *Les Amants*, a film about an *haute bourgeoise* woman having an affair, scripted by Louise de Vilmorin, was notorious on its release for its sexual frankness, showing a scene of Jeanne Moreau taking evident pleasure from oral sex. Such liberalism becomes a hallmark of Malle's films, as evidenced in the disturbing *Pretty Baby* (1978) starring Brooke Shields as a thirteen year old prostitute. *Pretty Baby* and the far finer *Atlantic City* (1980) date from a period when Malle went to the United States to make films. This move was inspired by the negative French reception of his first film to contend with the history of the Occupation, *Lacombe Lucien* (1973). The 1970s mark the opening of a cultural debate in France over the role played by some of the French as collaborators under the German Occupation. This issue is explored in a mythic register in Michel Tournier's novel *Le Roi des aulnes* (1971) and more generally in the fiction of Patrick Modiano throughout the decade. Modiano was the scriptwriter of *Lacombe Lucien* which addresses the issue head on. Where, in the 1990s after the death of Mitterand, and in the context of the trial of Papon, for example, the French have been far more willing to reprocess their collective history, *Lacombe Lucien* moved against the dominant cultural and historical climate with shock effect (see Jeancolas, p. 87).

Au revoir les enfants, contrarily, moved admirably in accord with public feeling. The film works almost too well as an appeasement piece. It is Malle's first film in French after the reception of *Lacombe Lucien* and it is a narrative of an extraordinary act of courage on the part of a French priest, le père Jean, in sheltering three Jewish boys in his school. The film ends with the denuncia-

tion of the priest by Joseph, the school's orderly, who bears a certain resemblance to Lucien of the earlier film. In voice-over we learn of the boys' and priest's death in the camps.

Au revoir les enfants is, despite its seeming efficiency, an extraordinarily fresh and moving film. Philip French, a critic and expert on Malle, describes the film as 'the finest French film for several years'. *Au revoir les enfants* is a retro piece which, like Truffaut's earlier *Le Dernier métro* (1980) or Chabrol's *Une Affaire de femmes* (1988), nostalgically recreates the era of the Occupation through attention to period detail and costume. This is felt in *Au revoir les enfants* in the image of the child protagonist Julien Quentin's mother who is resplendent with very red lipstick and sumptuous fur coat, and in the image of the boys' school uniform with their antiquated capes and short trousers. Yet *Au Revoir les enfants* is more than costume drama, it is indeed, importantly a personal history.

The main drama and focus of the film concerns the cautious, rivalrous but eventually strong friendship which develops between Julien and a new boy who arrives at the school, Jean Bonnet. Julien will become fascinated by Jean and his difference. He quickly works out that Jean is Jewish, not Protestant as he claims, and that he is in hiding in the Catholic school. The film explores the responsibility of Julien's knowledge and the way it leads him appallingly and inadvertently to betray his friend as he glances at him when their class is under Gestapo interrogation. This moment, and this involuntary glance, is the film's *raison d'être*. It comes very close to the film's dénouement but is prefigured visually at certain moments where Julien is caught glancing at Jean in the classroom, in the dormitory, in his piano lesson.

That Julien should be portrayed as observer is apt given his relation to the director himself. *Au revoir les enfants* claims part of its power from the knowledge, promulgated in publicity material around the film, that Malle himself is telling a story from his own past and that this is in this sense a very personal history. He says in interview with Philip French: '*Au revoir les enfants* is based on something that actually happened to me. The film is very close to my

own experience' (p. 167). This sense of the film as a form of fictional testimony is corroborated by the use of voice-over at the film's close where the director himself speaks directly to us: 'Plus de quarante ans ont passé, mais jusqu'à ma mort je me rappellerai chaque seconde de ce matin de janvier' (more than forty years have passed, but I will remember every second of that January morning until the day I die). It is as if the ground between past and present has been covered, as if Malle testifies to the indelibility of memory and the constant recurrence of the past. This ending is interestingly at odds with the retro mode of the film which serves for the most part to place the film's events safely in a self-contained past era.

The frankness and confessional tone of the film's last words are stirring and work with great effect. Their veracity, however, is placed in perspective as we read more about Malle's own implication in the events apparently represented in the film. Further into the interview with Philip French, Malle comments on the differences between the experiences he lived and the film he made. He says: 'I realised there were certain distortions, almost as if my imagination during those forty-five years had taken over and fertilised my memory' (p. 166). He adds: 'Memory is not frozen, it's very much alive, it moves, it changes' (p. 167).

The comment on memory seems telling, and in keeping with Resnais's exploration of the very vitality of memory. Yet Malle's film, more than an exploration of memory, seems to offer evidence of the ways in which film as medium, if popularly successful, organises and distorts reality. Malle tells of his experiences of talking about *Au revoir les enfants*: 'After the film was released, I went to talk in *lycées*, because teachers asked me to discuss the film with kids the same age as Julien and Bonnet, and it was always, "Did you really do that?"- almost as if I'd denounced him. As if it was me, not Joseph, who had done it. I kept telling them that they would have found him anyway. I didn't even bother to tell them that it didn't actually happen that way. I wrote it that way in the very first draft and left it because I thought it would make it more emotional for Julien. I never intended that Julien – or I – would seriously feel

responsible for Bonnet being arrested. Although maybe that's
what I was trying to say, unconsciously' (pp. 179-81). For many
viewers, as for Malle's *lycée* students, the emotional force and effect
of the film must surely come in the intimation of personal respon-
sibility which inhabits the voice-over testifying to permanent
memory at the end. Malle speaks of making the scene more emo-
tional for Julien; he fails to disclose here the sense that the film will
thus hold a greater power over its audience. His words show, if
unconsciously, that he is a perceptive judge of the viewer's
response.

In this interview with French, Malle seems to want to hold a
paradoxical position on his own relation to the events of *Au revoir
les enfants*. Where the film has claimed veracity from his stated per-
sonal involvement, when judgement of the character's actions turn
against Malle's intention, he adds, 'I didn't bother to tell them that
it didn't actually happen that way', telling us now and seemingly
rescuing himself from personal responsibility.

Perhaps his most interesting statement comes at the end of the
passage quoted, however, where he adds that maybe there was an
unconscious element in the film which has ironically been
revealed to him in the viewers' response. While claiming *Au revoir
les enfants* as a memory piece and testimony, Malle reveals the fic-
tions which enter (any) representation and the distortion of the
'truth' for artistic effect. Yet he reveals too the way in which a work
of art may uncannily escape its *auteur's* control. The viewers'
responses may reveal plural readings of the film, and may even lay
bare elements of the film as yet unseen or unavowed by the
director himself. This relates to the rereading of 'la politique des
auteurs' offered in Chapter 1.

Au revoir les enfants is also a personal history in its *intimiste* focus
on a particular friendship. As Julien becomes interested in Jean
and attempts to identify with his constant fear of denunciation,
the film provides the viewer with a point of identification in the
film. It is through Julien that we know and importantly fail to
know the full horror of Jean's experience. Jean is guarded and
often silent in the film, where Malle does not claim to be able to

give us access to his consciousness. This comes most effectively in moments which reveal the true sensitivity and care behind the film as a whole. One of these moments comes as the boys are watching a film, Charlie Chaplin's *The Immigrant* (1917), projected by one of the monks in the school refectory. There is pathos is the amateurish set up and the evident great pleasure which is taken in the film by monks and children alike. The film-viewing seems a break in the tension of Malle's own film. But from the boy's hilarity, Malle cuts to a shot of Julien and Jean's faces suddenly still and awed as they see an image of the Statue of Liberty on the screen in front of them. In Jean's response in particular, Malle seems to image all that the child hopes for and all that is beyond his reach.

Personal histories work to move or touch the viewer in ways that are often unreachable in more objective accounts. *Au revoir les enfants* is willing to move away from testimony into fiction in order to achieve its effects. This may in turn distance it from the importance of a commemorative piece such as *Shoah*, yet Malle's film, like Spielberg's *Schindler's List* (1993) has ironically reached a greater audience than Lanzmann's and thus provoked a wider response. The representation of history is necessarily bound up with questions of betrayal and treachery both in film as medium and in its content. These very issues will be seen to be partially obstructed, however, in the nostalgia pieces I will turn to in the following chapter.

Selected Reading

Cathy Caruth, *Unclaimed Experience: Trauma, Narrative, and History* (Baltimore, 1996).

Gilles Deleuze, *Cinéma 2: L'Image-temps* (Paris, 1985). In French. A very difficult, philosophical analysis of film, which nevertheless contains some marvellous insights into time and memory in Resnais's filmmaking.

Marguerite Duras, *Hiroshima mon amour* (Paris, 1971). In French. The script of the film, together with appended notes and comments from Duras.

Shoshana Felman and Dori Laub, *Testimony: Crises of Witnessing in*

Literature, Psychoanalysis, and History (New York, 1992). A ground-breaking study of testimony. Particularly interesting discussion of *Shoah.*

Philip French (ed.), *Malle on Malle* (London, 1993). A fascinating book of interviews with the director.

Claude Lanzmann, *Shoah* (Paris, 1985). In French. The script of *Shoah,* together with an introduction by Simone de Beauvoir. More readily available in English translation (New York, 1985). Translator not named.

James Monaco, *Alain Resnais* (New York, 1979). A good introduction to the director's work.

René Prédal, *Louis Malle* (Paris, 1989). A good, illustrated introduction to Malle's films.

Films

Shoah: Cahiers du cinéma, no. 374 (July-August 1985), pp. 15-23; *Monthly Film Bulletin,* no. 638 (March 1987), pp. 86-88.

Hiroshima mon amour: Cahiers du cinéma, no. 96 (June 1959), pp. 38-41; *Monthly Film Bulletin,* no. 313 (February 1960), p. 19.

Au revoir les enfants: Cahiers du cinéma, no. 400 (October 1987), pp. 18-22; *Monthly Film Bulletin,* no. 657 (October 1988), pp. 296-297.

6

Histories II: Nostalgia

1. *Tous les matins du monde*

In Pascal Quignard's novel *Tous les matins du monde* (1991) the reader waits until Chapter 26 for an explanation of the elliptical title. This, the penultimate chapter of the text, begins: 'Tous les matins du monde sont sans retour. Les années étaient passées' (Each day dawns but once. Years had passed, p. 124). Julien in *Au revoir les enfants* has echoed this sentiment when he says rather sententiously to one of his friends: 'Est-ce que tu réalises qu'il n'y aura plus jamais de 17 janvier 44. Jamais, jamais, jamais plus' (Do you realise that there will never be another 17 January 44. Never, ever, ever). Nostalgia film reminds us of the irrevocable passage of time, to allow us, in more rarefied ways, to enjoy the illusion of return it appears to offer, for the space of a feature film.

Tous les matins du monde was adapted as a film by Alain Corneau in 1991, with the assistance of Quignard himself. The film stands as an example of two types of work I want to look at further in this chapter: the literary adaptation and the historical drama. To describe the film as a nostalgia piece is perhaps to do it a mis-service, where nostalgia is frequently associated with false sentiment and retrogressive idealism. Yet *Tous les matins du monde*, despite its sobriety and elegance, nevertheless takes its place among a set of films produced from the mid 1980s onwards which have redirected the popularity of French cinema. A dominant strand in recent French cinema, which has gone largely undiscussed so far in this study, takes the form of heritage films which reprocess and represent France's literary, historical and cultural past. The popularity of such films is certain.

For some commentators, and this seems just, the dominance of the heritage film marks effectively a return to the 'tradition de la qualité' which Truffaut writes against and which has been associated with retrogressive aesthetic values. Historical film as such was certainly not dormant between the late 1950s and the 1980s, as witnessed in Truffaut's reinvention of the literary adaptation in *Jules et Jim*, in Eric Rohmer's forays into literary adaptation in *La Marquise d'O* (1975) and *Perceval le Gallois* (1979) or André Téchiné's historical drama *Les Soeurs Brontë* (1978). Yet its popular appeal came only latterly and with heightened gloss and more costly production values. Some view the whole phenomenon with extreme scepticism.

I have chosen to begin my introduction to the subject with a study of *Tous les matins du monde* since I think that this itself is a film which will help us understand the emotional investment in the heritage film as such, its dangers and its appeal. Prédal also accords the film pride of place in this doubtful new genre, writing: 'Dans le genre, on peut retenir comme archétype la belle évocation de l'univers de la création artistique proposée par Alain Corneau dans *Tous les matins du* monde' (an archetype in this genre is found in Alain Corneau's fine evocation of the world of artistic creation in *Tous les matins du monde*).

Tous les matins du monde is from its start, and in many ways, a retrospective piece. The film starts with a close up of the face of a supposedly elderly Depardieu, playing the court musician Marin Marais. Marin Marais is our guide to the narrative of the film as it unfolds. The body of the work will be narrated in voice-over by Depardieu. Frequently the words Depardieu speaks are drawn directly from Quignard's literary text. The film is marked thus by Quignard's sober and economical tone. It is also marked out in this way as a literary adaptation in the importance given to the very words spoken and the willingness to allow events and emotions frequently to be described rather than shown. Literary adaptations will indeed sometimes acknowledge their secondary status like this, and their debt to the power of the language of the text. Witness the use of voice over in the crucial late scene of Martin

Scorsese's wonderful adaptation of Edith Wharton's novel *The Age of Innocence*. Jeremy Irons's voice, animating the sentiments of Newland Archer, speaks Wharton's very words over the scene where Archer decides latterly not to visit Ellen Olenska whom he has loved and relinquished. In *Tous les matins du monde* the voice-over works to create an effective division between words and image. In parallel with Depardieu's narrative, the images of the film open up like so many *tableaux vivants* and even *natures mortes* (still lifes). This effect is only enhanced by the fact that Corneau always uses a fixed camera, offering us a still point of view on the images we watch.

Depardieu's voice-over takes us back to 1660 and marks the ways in which the film will work as tribute to and memory of Monsieur de Ste Colombe, a real seventeenth-century composer, Marais's *maître*. The film exploits the familiar division between the ascetic and the worldly, between the pure artist and his lesser counterpart, as it is Marais who wistfully tells Ste Colombe's story. Corneau makes a film about austerity which celebrates the integrity and unworldliness of the ideal artist. Yet, despite the simplicity of the film's cinematography, Corneau himself works with high production values and sumptuous trappings. It is as if, in adopting Marais's perspective, the film offers an internal comment on its own status. The distance, both literal and stylistic, between point of view and object viewed also adds to the poignancy of the narrative itself.

Within its very structure *Tous les matins du monde* is already a memory piece, about the irrevocable loss of the past. We will learn too that loss marks out Ste Colombe's life, music and destiny. The first event of Ste Colombe's life of which we learn is the death of his wife. This loss remains an open wound in the film. The tranquil voice-over tells us: 'Il ne se consola pas de la mort de son épouse' (he couldn't get over his wife's death). His music becomes a means to mourning his wife and (quite literally) to summoning her ghost. Corneau plays with the illusions film can offer of a phantom existence, where Ste Colombe's wife is seen to sit before him as he plays. The music he composes, in particular 'Le Tombeau des

Regrets', expresses the sentiments of love and loss that Ste Colombe never himself places in language. There is a sense indeed that music replaces words in the film. This displacement motivates Marais's decision to come to take Ste Colombe as his *maître*. The young Marais (played aptly by Depardieu's son Guillaume) comes to the Ste Colombe household to speak of his own loss. He has been a child soprano but now has lost his voice. His desire is to master the viola da gamba, the instrument Ste Colombe plays. We have learnt in the film that the viola da gamba can imitate the range of sounds of the human voice. For Marais it will be the fetish which both denies and acknowledges the loss of his voice. Music, and in particular his piece, 'La Rêveuse', displaces language in his relation to Ste Colombe's elder daughter Madeleine.

Music is seen to animate interrelation in the film and to become a means of expression. This is important in the film's reception as much as in its narrative. In its evocation of seventeenth-century music, *Tous les matins du monde* guarantees its status and popularity in cultural terms. It provoked renewed interest in the viola da gamba (as films such as *32 Short films about Glenn Gould*, 1993, or *Shine*, 1996, encouraged sales of recordings from their respective subjects). Classical music is important in the heritage film more generally, as in the use of Verdi in *Jean de Florette* (1986) or indeed Puccini in *A Room with a view* (1985).

But *Tous les matins du monde* does not merely use music to evoke place, memory and emotion as elsewhere. It also claims for itself the status of other recent art movies which have taken classical music as their subject and explored the interrelation between music and film as art forms. Think for example of Claude Sautet's *Un Coeur en hiver* (1991) or Krzysztof Kieślowski's *Trois couleurs: bleu* (1993). In both these films music is used to express the inexpressible. In *Un Coeur en hiver* the passionate playing of Ravel fills the emotional void of a film which takes repression as its subject. In *Trois couleurs: bleu*, music recurs as a form of traumatised memory for Julie, the composer's wife who has lost her husband and child in a car accident.

Contemporary art cinema appears to emphasise the ways in

which cinema is auditory as well as visual. Music is exploited for its expressive capacities, yet also becomes a guarantor of aesthetic value.

A similar point might be made with relation to the position of paintings in film and allusions to art history. As cinema claims high cultural status, it marks out the proximity between film and painting. Godard questions and comments on this in his visual allusions to Picasso, Renoir and others in *A bout de souffle* and *Pierrot le fou*. Similar interrogative work is done by Agnès Varda in *Jane B, par Agnès V*. Cinema has also frequently taken the life stories of artists as its subject, as in Maurice Pialat's *Van Gogh* (1991) or Bruno Nuytten's *Camille Claudel* (1988). In *Tous les matins du monde*, Corneau makes reference to painting as a parallel art to music. Ste Colombe seeks a *nature morte* which will depict the scene in his *cabane* where his wife's ghost has visited him. The film frames both the set scene itself, and a painted representation of it. The similarity between the two images works to liken Corneau's own art to painting.

This effect is achieved further by the use of a still camera (as we have seen) and by the very deliberate painterly *mise-en-scène*. This is particularly noticeable in the film's pastoral scenes which insistently (and anachronistically) evoke the landscapes of the nineteenth-century painter Corot. Corot himself presented a pastoral idyll of rural France. Corneau borrows the nostalgia of these images, their visual beauty, mists and reflective pools. Mood is seen to take precedence over evocation of the art of a specific period. Elsewhere, however, in the interiors in particular, Corneau comes closer to evoking the simplicity and sombre colours of seventeenth-century domestic scenes.

Tous les matins du monde demonstrates the ways in which our popular memories of the distant past are influenced by the forms of high art. The memorial status of music and art is celebrated. Yet that mnemonic capacity is revealed in the film to be at its most intense in the personal register. To dwell on the nature of the nostalgia piece as such, Corneau (with Quignard) takes as his focus a personal history, the history of the austere and hidden Ste

Colombe. Where Ste Colombe's still life is encrypted within the outer layers of public history and the court of Louis XIV, it remains the still point, the focus of the film's attention, of Marais's burden of memory. Where Monsieur de Ste Colombe laments his lost wife, Marin Marais, in this self-conscious heritage film, laments his lost master and his lost idealism. Corneau exploits the illusions which foster the heritage film, the desire to relive the past such films both nourish and inflate.

2. Imagining Provence

Where Corneau creates a lush, pastoral France, Claude Berri has provided French cinema with a locus of memory and nostalgia which has proved unimaginably fertile. Imagining Pagnol's Provence has become more than a type of cinematic tourism. This landscape of ravishing beauty, which Berri idealises still further, has come to hold specific meanings in the popular imagination, meanings exploited in advertising, in travel guides etc. The films *Jean de Florette* and *Manon des sources*, beyond doubt the most successful French heritage films in the UK at least, make a myth of the relation between the individual, his landscape and his personal destiny. As Guy Austin comments, 'Berri's achievement in both films is to eschew the public space of the heritage genre in favour of a private tragedy concerning disputed heritage' (p. 160). Indeed, taking Austin's comments one stage further, I would say that the heritage genre always depends, in its emotional impact, on a personal history within a public context. This is witnessed for example, in Berri's later *Germinal* (1993) which, as an adaptation of Zola's novel, works to represent the miners' strike in part through its impact on a particular family. Zola's fictional family is doubled by Berri's cinematic family, where he selects Gérard Depardieu and Miou-Miou, such familiar icons in French cinema, to play Maheu and La Maheude. The familiarity and appeal of the actors guarantees the audience's return to the film.

In my discussion of Berri's films, I will argue that the familiar and the family are the key to the overwhelming impact of the

genre in which he has found such success. Commenting on the relative lack of innovation in 1980s cinema in France, Prédal argues that even *Jean de Florette* and *Manon des sources* may be seen as a type of remake. This is literally the case with the latter film and by implication with *Jean de Florette* itself. Marcel Pagnol, novelist and filmmaker, made a film, *Manon des sources* in 1952. This he then developed in a two part novel, *L'Eau des collines*, telling Manon's story and adding the prequel with its specific focus on Jean de Florette. Where Berri's films are far more polished and spectacular than Pagnol's, he is nevertheless fairly faithful to Pagnol's interpretation and aesthetic. Vincendeau (1996) speaks of Pagnol's 'archaic patriarchal values'. Interestingly these are embodied in both form and content in Berri's remakes.

Jean de Florette and *Manon des sources* are emphatically films about filiation and lineage. This is seen in different ways in the very titles of the two films. The first marks Jean's relation to his mother, Florette; the second marks Manon's relation to the landscape which is the symbolic heritage she has taken on from her father. Berri celebrates a pattern of filiation, remaking Pagnol and inserting himself in a certain family history of popular French cinema. (As Vincendeau reminds us, Berri's cinema is both populist and popular). Further he creates his own line of descendance, manifested importantly in the creation of two films, *père et fille* as it were, where the second part contends with the heritage of the first. Interestingly, Berri's Pagnol remakes have also spawned their own bastard line in the later adaptations of *La Gloire de mon père* (1990) and *Le Château de ma mère* (1990) by Yves Robert. Guy Austin describes the making of these films as an 'apparently cynical attempt to emulate the format and thus success of Berri's Pagnol adaptations' (p. 162). Their success only seems further to authorise Berri's diagnosis of the needs and pleasures of the cinema-going public.

For Berri, cleverly, the heritage film will take root in the public imagination if it takes inheritance and family heritage as its subject. It is only apt that he will go on to film Zola, the great novelist of the family and genetic destiny. Indeed in *Jean de Florette*, when

Jean arrives at Romarins and extols the beauty of the countryside, he alludes precisely to 'le paradis de Zola'. This works in the film to show up Jean's bookish nature and literary ideals of Nature itself. Zola, given his origins in Provence, is a familiar reference point. Yet this reference also offers a clue to the themes of inheritance and heritage that Berri will emphasise as his subject. For Berri, however, as opposed to Zola, the family is celebrated, and filiation is a source of power.

Jean de Florette sets up two families. These begin in opposition but will prove inevitably entwined. On the one hand, Berri creates a symbolic, rather than literal, father and son in the figures of César and Ugolin Soubeyran (Yves Montand and Daniel Auteuil). Although Ugolin is César's nephew, rather than his son, between them this couple appears to embody a father-son pact, and homosocial bond. Ugolin calls César 'Papet' indeed, evoking his paternal authority. It is César who will guide Ugolin through the plot to re-route the spring which is the source of both films, the subject of their conflict and their final resolution. This pair work partly as a comedy duo in the film. They work also to represent the cunning and knowledge of the local in opposition to the idealism of the urban outsider in another familiar dualism invoked by the film. Yet the fate of the Soubeyrans is more serious when one considers the overall ideological impact of the film.

The bond between César and Ugolin is seen on some levels to be false: Ugolin is César's replacement for the son he might have had. César himself believes that he has had no offspring and as he grows older is manifestly concerned about the future of his line and of the inheritance he will leave. Ugolin also has not married (although he finds comfort with prostitutes) and has no offspring. His romantic attachment to Manon in *Manon des sources* is hopeless, leading to his humiliation, mutilation (as he sews a ribbon as love token to his nipple and it becomes a seething abscess) and his final suicide. Very overtly, patriarchy and masculine power as such are seen to depend on the continuance of the family line. The false relation between César and Ugolin is ultimately punished in the discovery of their plot and the losses they will both undergo.

Where the false line ends in death, the truth of the true line will ultimately out.

César is punished too for his lack of knowledge of his true line of descendance. Near the end of *Manon des sources* there is a rather wordy revelation scene where César meets Delphine, an elderly woman from the village. Delphine reveals that Florette became pregnant with César's child (Jean) and wrote to tell him while he was away fighting in Africa. Receiving no reply, she married another and moved away. Of course, César never received her letter. This stroke of fate seems worthy of a novel by Thomas Hardy. César's romantic life has been wasted. He will die clutching one of Florette's haircombs which he has kept all these years (the endurance of love being another trademark of the heritage movie). Yet his genetic function has been fulfilled, if unwittingly. The tragedy of the pair of films, which we come to know only in its ending, is that César has proved partly responsible for his own son's ruin and early death. The films' reparative gesture comes however in Manon's fertility and in César's will. He will of course leave his fortune to Manon, who has herself married the village schoolmaster. She is reassuringly pregnant, with another small Soubeyran in race if not name, in her last appearance in the film.

Jean de Florette and *Manon des sources* seem to reveal, ultimately, that nature will out, that the spring will flow again and the Soubeyran line will continue. These are the family values the film fosters. As Phil Powrie comments, 'a profoundly conservative hankering for the certainty of a hierarchical rural social order is coupled, unsurprisingly, with an Oedipal configuration of a return to the origin' (p. 61). Berri makes the dynamics of the family romance his subject, in part, yet unlike Zola, he appears to celebrate its values and efficacy. The psychic material which might be unearthed in César Soubeyran's battle against his son, Jean de Florette, could be lurid and revelatory. But there is not the least intimation that César has guessed his son's identity or pitted himself, even unconsciously, against a filial rival. Furthermore, the films leave entirely unexplored any tension in Jean's own family.

He is tended and supported by two ravishing women, his wife and daughter. The films simply leave no space for possible female rivalry over the rather appealing patriarchal object of desire that Jean represents. Mother and daughter are united in their defense of Jean and his idealism. This again is one of the points of reassurance in the heritage film: the family becomes a haven in which the father's values reign.

Indeed, it is telling that in their patterns of filiation *Jean de Florette* and *Manon des sources* depend on a father/daughter relation rather than a father/son relation. In the Oedipal configuration, it appears that the daughter will be a safer protector of her father's name and power. In this sense, I think there is no lurking feminist agenda in the primacy given to Manon in the latter film. She remains instead a token of her father's power. She embodies certain patriarchal myths of femininity in her relation to nature. Despite the supposedly historical setting in the 1930s, Manon seems at first a mythic rather than realist figure. She is figured as fairy or witch, source of arcane power, in harmony with nature. She rarely speaks but makes unearthly noises instead to her little herd of goats. She is seen bathing naked in a pool on the mountainside and dancing in the sunlight. The adult Manon, as played by Emmanuelle Béart in *Manon des sources*, bears a striking physical resemblance to the child Manon of *Jean de Florette*, yet emotionally and at the level of representation she is transformed. Phil Powrie accounts for this in terms of the film's diegesis (or narrative) suggesting that she may have gone 'wild' after the trauma of discovering the plot against her father. It seems that at a deeper level, *Manon des sources* seeks to revive a myth of female fidelity, mysticism and savage love, and recognises that to make this in any way plausible it must move beyond realism into myth.

Manon will of course avenge her father. *Manon des sources* faithfully revisits the sites and dramas of *Jean de Florette*, rights the wrongs of the first film whilst commemorating its pleasures. In some senses Berri asks us to see the same film twice, allowing the second version to appease us for the cruel fate and tragedy of the first. In this way too the sequel is its own form of return. It repre-

sents return, too, as Manon literally goes back into the earth in the symbolic crypt in the mountainside where she finds the source of the spring. The water will return to Romarins and to the village. The theme from Verdi's aptly titled *Force of Destiny* which has echoed so insistently through *Jean de Florette* will again return in *Manon des sources*.

One strength of the films, ironically, lies precisely in the way in which they analyse and re-encode the psychological investment in the heritage movie. Heritage films are not merely about escapism and the finding of a historical or pastoral paradise which exists outside everyday reality. Instead they work to reconfirm the very myths which prop up the reality in which we live. They offer false truths about family values, fidelity and filiation. Indeed the brilliance of *Jean de Florette* and *Manon des sources* lies in the way they allow viewers to confront fears of the failure of masculinity and patriarchy (in Jean's failed ventures and death, in the tragedy of the Soubeyrans) only to assert the reparative power of the dutiful daughter and the strength of the line, its symbolic power, despite individual failure. Over and above their visual beauty and lyricism, these films are deeply reassuring on a psychological level. Redemption and revenge offer coherence in these two personal histories. The heritage film marks the place of the individual within a broader lineage and thus acquires its power.

Perhaps it is worth noting too that *Jean de Florette* and *Manon des sources* have proved more successful and iconic with British audiences than with the French public. While both films drew large French audiences, neither was the best selling film of the season 1985/1986: both were beaten at the French box office by Coline Serreau's baby comedy *Trois Hommes et un couffin* which had to be remade as the American *Three Men and a Baby* before it gained international success. *Jean de Florette* has proved highly popular with British audiences. This works to underline the importance of nostalgia in reception as much as in representation. The film benefits from its distance in represented time, space and language from its British audience. Yet the idyll of the family and Provence it evokes

is still readily accessible to holiday makers, and often a trigger of holiday memories.

This British love affair with the French countryside is explored in Tavernier's aptly named *Daddy Nostalgie* (1990). This again is a father/daughter film, but supposedly in realist mode. Dirk Bogarde plays an ailing Englishman who has settled in the South of France with a French wife. Jane Birkin plays his adoring daughter. The film works to uncover some of the false relations inherent in nostalgia and explores the filmic devices, such as flashback, voice-over and popular music (the song 'These Foolish Things'), which serve to represent such themes. In this it differs from the smooth surface and illusions of the heritage genre. The awkwardness between the adult daughter and her frail parents is brought to the fore. The independence of the daughter is stressed in the scenes which frame the film as we see her Paris apartment (decorated in pale, neutral colours, with books and a Man Ray poster of a sleeping woman). Her trip to the South of France is an excursion into her past where she finds herself out of place and out of joint. With some sentimentality, the film ends with voice-over narration of the father's death. Despite the pathos of the ending, *Daddy Nostalgie* (like Téchiné's more restrained *Ma Saison préférée*) is left ultimately unresolved in its treatment of relations between parents and their adult children. Nostalgia is placed in a real social context. Nostalgia in the heritage film, contrarily, is assuaged by the illusion of the permanence of the values it attempts to uphold.

3. Fetishism and Costume Drama

The final film which I will look at in this section nevertheless holds very different values from *Jean de Florette* and *Manon des sources*. We've seen so far that heritage cinema can uphold values of high art in section 1, and of the family in section 2. In turning now to Claude Chabrol's adaptation of *Madame Bovary* I want to show how a heritage film can function as *auteur* cinema, whilst also, inevitably, being bound up with the questions of the past and its

restoration which run through the genre as a whole. In *Madame Bovary*, however, these questions will be reviewed, together with the future of the genre as such.

Claude Chabrol is seen by many as the father of the *nouvelle vague*. His early films, *Le Beau Serge* (1957) and *Les Cousins* (1958) afforded new subjects, and new ways of filming in French cinema. He has gone on to gain particular renown for his many psychological thrillers which pursue the dominant theme of his *auteur* cinema which is, in Vincendeau's words, 'the dissection of the French bourgeoisie'. Given this major current in his work, no literary text could be better suited to his cinematic canon than Flaubert's novel, *Madame Bovary*. Vincendeau describes this as Chabrol's excursion into the heritage cinema genre, which indeed it is. That he should choose to make his mark latterly in this genre seems faintly paradoxical given his *nouvelle vague* origins. Yet Chabrol's *Madame Bovary* is, as I have suggested above, very much an integral part of his entire corpus of works. Indeed it offers Chabrol the opportunity to revisit some of the sites and tensions of his perhaps most celebrated and resonant film, the thriller *Le Boucher* (1970).

Le Boucher stars Stéphane Audran as a village schoolmistress, Mademoiselle Hélène, who becomes gradually embroiled with the disturbing local butcher. The film plays on the fixity and asphyxiation of village life, showing the schoolmistress and butcher finding a peculiar camaraderie as they both exist in part as outsiders. This bond is threatened and tested as Mademoiselle Hélène becomes aware that the butcher is guilty of a series of brutal murders which slash through the village. The tension of the film is recalled as cinematic intertext and undercurrent in *Madame Bovary*.

Chabrol's adaptation has been marketed (and conceived) by the director himself as a strictly faithful work. Chabrol has been quoted saying: 'The idea which prevails throughout this adaptation of *Madame Bovary* is absolute fidelity. It was neither a question of a "reading" nor of a particular emphasis. The aim, perhaps a little crazy, is to make this film in a way that Flaubert would have done'. The aim is partly achieved (and Chabrol has been criticised

by some for his academic fidelity). Yet *Madame Bovary* the film is, nevertheless, pure Chabrol.

Isabelle Huppert, who is cast as Emma (beautiful for the part, though perhaps too old), is reminiscent of Stéphane Audran in *Le Boucher*. She is frequently filmed by Chabrol against window frames, looking out or silhouetted (as Emma is indeed described in the novel). Yet here Chabrol also recalls shots from *Le Boucher* where the windows of the schoolhouse both frame Mademoiselle Hélène and the outside world she views. Emma and Mademoiselle Hélène find themselves in a broadly similar, stifling small town environment. Mademoiselle Hélène and the butcher meet early in *Le Boucher* at a wedding breakfast. Chabrol can recall his former film in detailing Emma's wedding, again faithful to the text, early in *Madame Bovary*. Both films find different means of taking a scalpel to the French bourgeoisie: *Le Boucher* through the crimes of the butcher (traumatised by his war experiences in Indochina), *Madame Bovary* through the botched operation on Hippolyte's foot which we see in close up in all its festering detail. Indeed in *Madame Bovary* Chabrol seems keen to cut through the glossy surface of the heritage film, revealing, like Flaubert in his heroine's death, for example, a far crueller and more candid image of the past than cinemagoers generally meet. This trenchant revelation of visual and visceral detail is significant, however, and places *Madame Bovary* within a new and recent trend in the French heritage film.

Accused of escapism, French directors of historical and literary dramas seem increasingly inclined to let disease and mayhem run riot in their films. Guy Austin comments on the carnage in *La Reine Margot* (1994) for example, saying: 'the painterly tableaux beloved of the genre present a horrific spectacle, that of the dead and dying in the streets of Paris, reminiscent of images from the Holocaust or from Bosnia' (p. 169). Such a reading immediately gives the heritage film a present resonance. It might be argued, indeed, that historical drama can be used to remind us of the mnemonic and significatory power of particular recurrent images. In this sense the division I have created here between trauma and

films and nostalgia films would seem to be crossed. Austin comments on the way the representation of trauma in the heritage film 'breaches the normally assured, touristic distance between spectator and spectacle' which is a mark of these films. He cites the images of the still or frozen bodies after the battle of Eylau in Yves Angelo's Balzac adaptation *Le Colonel Chabert* (1994). But one could think too of the graphic images of cholera victims in Jean-Paul Rappeneau's otherwise sumptuous Giono adaptation, *Le Hussard sur le toit* (1995). Such bodily damage does change the viewing relations of these films. Yet I think that rather than seeking purely to bring their spectators closer to historical reality, these films also open up a voyeuristic interest. Topping box office charts in the same years in the early 1990s are of course the new brand of bloody thrillers generated by Tarantino. The heritage genre seems to partake in this new popularity of bodily rupture. Horror is still spectacle in heritage film. It just works with different psychological effects.

The poster which publicised *La Reine Margot* shows Isabelle Adjani as the eponymous heroine in a fine white silk dress and pearls. Her hands are lifted to her face in horror. Her dress is literally drenched in blood. The deep crimson of the blood seems to seep into the red background of the poster against which Adjani appears outlined like a puppet or a ghost. She becomes a new icon of the heritage drama: her costume, and its finery, now bear the marks of the trauma it is designed to hide.

Costume is of course one of the greatest pleasures of the heritage film and one of the most overt ways in which it expresses its production values and even its aesthetic image. This can be seen very much in Scorsese' s *The Age of Innocence* or Ian Softley's Henry James adaptation *The Wings of the Dove*. Costume in Chabrol's *Madame Bovary* serves to carry much of the sensual force and pleasure of the film. The attention to detail also marks Chabrol's painstaking desire to recreate the very textures of Flaubert's novel. Isabelle Huppert's dresses were created by Corinne Jorry from portraits by Winterhalter and the Dubuffe brothers. They were made by Bernadette Villard from the Berman-Traonouez workshop. The

material used largely dated from the nineteenth century, pieces being bought at the fleamarkets in Paris, or made on handlooms by the Soyeux-Lyonnais silk manufacturers. This almost excessive attention to authenticity and verisimilitude seems justified in a different way by the very precision of Flaubert's style and his own attention to the minor details of feminine dress. Isabelle Huppert moves through the film in an array of totally gorgeous clothes. She begins in virginal white and progresses through her marriage and adultery into rose pink and dove grey and an illicit scarlet evening dress, then gauzy black silk with fitted bodice, dashing hats with veils and ribbons, and trailing laces. Again and again her clothes lay bare Emma's temperament, her elegance, her frivolity, her sexuality. In the novel, Flaubert makes Emma a clothes fetishist as the garments and fabrics Lheureux the haberdasher offers her seem costumes for the roles she desires to play, and veils to hide the tawdry reality of her life.

Chabrol's film is particularly effective in capitalising on this element of Emma's pathology. Occasionally the film may seem clumsy as literary adaptation: for example, where Huppert speaks aloud certain lines from the novel which could only work as interior monologue or *style indirect libre*. Or where Chabrol has too heavy recourse to voice-over, in order to tell as well as to show, where Flaubert's novel is a miracle of insinuation. These infelicities only work to show up further the ways in which Chabrol has been sensitive to *Madame Bovary* as a novel of spectacle, as a novel which envisages the imagination as a stage for the performance of identity. Chabrol exploits the potential of narrative cinema to reveal the desired theatricality which will take Emma beyond her everyday life. Chabrol shows the brief interludes of luxury and illusion in Emma's banal existence: the ball at Vaubyessard, the opera at Rouen. He shows her as she models herself on fashion plates, letting the viewer share Emma's sensory pleasures or appreciate their incongruity. Here he matches the novel's ambiguity, its pathos and its irony.

In her fascinating recent book, *Undressing Cinema*, Stella Bruzzi argues that costume films either encourage us to look through the

clothes or look at them. In films where we look though the clothes, their main function is to signal period and historical accuracy. Where we look at the clothes, Bruzzi argues, they come to privilege eroticism. This is certainly the case with Chabrol's *Madame Bovary* where Emma's clothes stand out from those of the other protagonists around her, to be looked at and not looked through. Bruzzi suggests that in cinema we should recognise the ways in which clothes function independently of the body, carrying their own discourse and fetish status. While this seems persuasive given the ever-evolving mirage of dresses we find in *Madame Bovary*, Bruzzi's argument underplays the bodily source of the fetish itself (in Freud's terms at least). For Freud, fetishism originates in a vision of bodily trauma: the child perceives that the mother lacks a penis. This is supposedly a literal response to female anatomy. This terrifies the (boy) child since it means he may lose his penis too. To guard against this embodiment of his fear of castration the child becomes fixated on the last object viewed before the traumatic encounter: shoes, silk stockings, or substitutes for pubic hair such as fur and velvet. This is the fetish object which holds uncanny power. The fetish conjures the illusion of a phallic powerful mother (see Chapter 4). Yet simultaneously fixation on the fetish acknowledges the loss and new knowledge found in the view of the mother's genitals. Disavowal (or denial) becomes the strategy of the fetishist: the fetish embodies a type of doublethink where female castration is both affirmed and denied.

We may choose generally to reject Freud's theory (and overdependence on the castration complex). For some it seems very implausible. What seems evident, though, is the way in which this theory helps us understand the role of clothes fetishism in *Madame Bovary*. Emma's clothes, ever more outlandish, become so many ways of manifesting her power. The masquerade of femininity she puts on works for a time to hide her disenfranchised status. She is symbolically 'castrated' in the film (and novel) where Flaubert makes the limited destiny of the bourgeois woman his subject. Her costume is a means to deny her 'castration', to cover the bloody wound which symbolically marks her body. What Chabrol's visceral

realism reveals ultimately, is that the blood will 'seep through the bandage' and that the fetishes, the wonderful garments, will lose their appeasing and alluring power.

Costume as fetish does not function independently of the body. Clothes as spectacle cover an imaginary site of bodily trauma. Interestingly, recent costume drama seems to attempt to draw attention to its own illusory status. Where the blood spattered costume becomes the very emblem of *La Reine Margot*, we find directors seeking to reveal what the costumes, and indeed the costume drama as fetish, attempt to disavow. This is where the heritage film now draws sustenance and renewed psychological interest. The heritage film has begun to uncover and reveal its own role in hiding trauma, in offering a veiled and continent view of history. This will be its future strength.

Selected Reading

Guy Austin, *Claude Chabrol* (Forthcoming).

F. Boddaert *et al.*, *Autour d'Emma: Madame Bovary, un film de Claude Chabrol* (Paris, 1991).

Stella Bruzzi, *Undressing Cinema* (London, 1997). A fascinating study of costume in film. Little on French material, but a useful point of reference when considering the heritage film.

Phil Powrie, *French Cinema in the 1980s: Nostalgia and the Crisis of Masculinity* (Oxford, 1997). See particularly the excellent discussion of heritage film in '*Jean de Florette* and *Manon des sources*: Nostalgia and Hysteria' (pp. 50-61).

Pascal Quignard, *Tous les matins du monde* (Paris, 1991). A concise and limpid novel. Well worth reading in conjunction with viewing the film.

Films

Tous les matins du monde. Cahiers du cinéma, no. 450 (December 1991), pp. 4-5; no. 451 (January 1992), pp. 62-70; *Sight and Sound*, vol. 3, no. 1 (January 1993), p. 54.

Jean de Florette. Cahiers du cinéma, no. 387 (September 1986), pp. 49-50; *Monthly Film Bulletin*, no. 642 (July 1987), pp. 208-209.

Manon des sources: *Cahiers du cinéma*, no. 391 (January 1987), pp. 52-54; *Monthly Film Bulletin*, no. 646 (November 1987), pp. 337-338.

Madame Bovary: *Cahiers du cinéma*, no. 442 (April 1991), pp. 58-59; *Sight and Sound*, vol. 3, no. 7 (July 1993), p. 47.

7

Paris: City of Light

1. Paris, Cinematic city

Paris is *the* artistic, architectural and psychological space of *nouvelle vague* cinema. *Les 400 coups* opens with a lavish and loving tracking shot through the streets of Paris. As the film's poignant signature tune plays out, the camera moves slowly, steadily down residential streets, guided by the iconic image of the Tour Eiffel, which becomes a point of orientation, always emerging into view. The camera then slides past the façade of the Palais de Tokyo, its columns silhouetted against the sky. These abstract patterns are echoed in the images of leafless branches and then in the fretwork of the Tour Eiffel itself as the camera reaches its destination and turns about it, under it, then slowly recedes once more as the opening credits roll on the screen. Truffaut's Paris is an aesthetic space and also a personal one. This is felt, in particular, in the filming of Montmartre, Truffaut's own *quartier* in Paris. In *Baisers volés* the city becomes a surreal underground map where the camera literally follows the course of a telegram along subterranean tubes from one end of Paris to the other (this laproscopic view is copied in Kieślowski's *Trois couleurs: rouge* where the camera appears to follow phone wires beneath the Channel). Rather than acting as a fixed set, Paris in French cinema is a city continually reinvented, literally and figuratively re-built and reviewed from different angles of vision.

Moving on from considerations of the aesthetic and autobiographical, I want to look here at the ways in which the filmmaker may be seen to work as ethnographer (a human scientist who specialises in the races of the world) capturing a view of a specific

environment (here urban) and its inhabitants, charting the inter-action between personal and public space. The city here will be seen as an ideological space, a space which is marked by social and cultural values and carries particular meanings in these terms. Filmmakers will be seen to explore individual perspectives, and in particular the point of view of the outsider, in order to explore these meanings and the relations of inclusion and exclusion they regulate implicitly or explicitly.

The image of filmmaker as ethnographer has a literal source. One of the filmmakers who is most associated with the filming of Paris is the ethnographer Jean Rouch. Rouch studied ethnography in Paris and went on to make documentaries in Africa in the 1940s and 1950s, using a portable camera and direct sound. He brought the same techniques to his ethnographic view of Paris, witnessed in *Chronique d'un été* (1961), a film he made with Edgar Morin in which a cross-section of Parisians are asked the question: 'Etes-vous heureux?'

Ginette Vincendeau (1996) suggests that the marriage of *cinéma-vérité* and the *nouvelle vague* can be seen particularly well in Rouch's short 'Gare du Nord' which made up one episode of the film *Paris vu par ...* (1964), a series of six short films by Godard, Rohmer, Chabrol, Jean Douchet, Jean-Daniel Pollet and Rouch himself. Although it lasts twenty minutes, 'Gare du Nord' is shot entirely in two takes. It is memorable in terms of the record of the city and particular *quartier* it offers. The film opens with a long shot of Sacré Coeur. The camera then moves down to pass over the roof of the Gare du Nord. It swings round to focus on a crane which hangs over the building site whose deafening noise has preceded the first images of the film. Later in the film a key scene takes place on the bridge over the tracks of the Gare de l'Est at rue Lafayette. The viewer is placed, as it were, architecturally and geographically in Paris. Yet the space is immediately one of re-building in the focus on the *chantier* (building site) next door, and in Odile (Nadine Ballot), the female protagonist's fears that her view will be spoilt by the building next door. The cinematic space is implicitly cited as one of commemoration: the lost spaces of Paris are fixed

on film, as filmmakers focus on the very work of re-construction which again and again changes the metropolis.

This same dynamic animates a recent film, Cédric Klapisch's tart comedy *Chacun cherche son chat* (1995), which works in some ways as a tribute to Rouch. Rather than building work, insistent music plays over the opening credits. This is music which irritates the neighbours of the *quartier*, the 11e arrondissement, which Klapisch will chart as his subject. The first image of the film is a panoramic view of the rooftops of the district, with a large crane in the middle distance. On the surface the film is the tale of Chloë (Garence Clavel), a skinny make-up artist (who physically resembles Nadine Ballot), and her black cat Gris-Gris who is lost during much of the action. But, more seriously, the film works to excavate and commemorate a changing area of Paris. The neighbourhood is a hybrid, split between cool cafés like the real Pause Café which is a central location in the film, and neighbourhood shops and bars. The community who live here are the film's real interest, however.

Radiating out from Madame Renée, the cat-sitter who has lost Gris-Gris, Klapisch charts a network of elderly women who help Chloë look for her cat. These women, often played by non-professional actors and filmed in their own homes, are shown to be the dwindling population of the neighbourhood as they are evicted from their small apartments in anticipation of gentrification. (Many previously working class districts of Paris are being re-developed to become fashionable neighbourhoods.) As Chloë walks through the streets putting up posters in search of her lost cat, we see the changes in the very fabric of the city as the crane demolishes a building opening a gaping hole in the landscape. Klapisch films the graffiti-covered hoardings which surround the *chantier* in images reminiscent of the graffiti of *Nikita* yet carrying now a commentary on the changing urban space. This space is particularly desolate in a memorable scene where Chloë, Madame Renée and one of her friends go to examine a dead cat in the rubble, still looking for Gris-Gris. The film hints at their alienation. Yet it revives, too, a sense of a transformed urban community, dwelling

affectionately on the relations between Djamel (Zinedine Soualem) and the elderly women he knows and helps, showing the friendship between Chloë and her gay flatmate Michel.

Chacun cherche son chat is one of a generation of films which makes Paris its subject, and shows its subject differently. It might be compared, for example, to Eric Rohmer's *Les Rendez-vous de Paris* (1994) which, through its rather incidental narratives, takes its viewer on a geographical tour of old and new spaces in Paris: the Parc de la Villette, the Parc de Belleville, yet also Montmartre and the area round Beaubourg. Human intrigue is second to architectural and spatial interest in Rohmer's film. In Klapisch's film, human and urban interact so the changes in each gain new poignancy and meaning. (This concern with the constraint and psychology of environment resurfaces in Klapisch's next film, another sharply observed comedy, *Un Air de famille*, 1996). *Chacun cherche son chat* also demonstrates an interest which becomes increasingly common in French cinema from the 1970s on: young women in the city.

2. Girls in the City

Where the Parisian landscape of the *nouvelle vague* is a space largely of male subjectivity, and of amorous encounters, in the 1970s and later a new focus is found on (young) women in the city and their place as observers in an urban environment. Here French cinema evokes its debts to the visual arts of the late nineteenth century and shows how its focus can change. The nineteenth-century city was radically altered by the re-building programme directed by Baron Haussmann. This brought the Grands Boulevards to Paris and opened up the city's vistas, viewpoints, leisure and work spaces. A record of this changing city and its impact on urban living is found visually in the work of the Impressionist painters who not only represented the new boulevards and parks, but adopted in their own angles of vision the new perspectives on the city offered by Haussmann. Typical of this is Monet's overhead view, *Boulevard des Capucines* (1873), or Caillebotte's *Jeune homme à sa fenêtre* (1875)

where we see a young male figure silhouetted against an open balcony window as he looks out at the bright street below. These are the very viewing positions adopted by Truffaut in particular as he offers the spectator a personal perspective on Paris.

Feminist art historians have noted the relative exclusion of women from the urban spaces represented in nineteenth-century art. Griselda Pollock, for example, has argued that the interior is the space of femininity in nineteenth-century French art (witness the interior scenes painted by Morisot and Cassatt). In the nineteenth century there is no female equivalent of the *flâneur*, the Baudelairean young man who wanders through the city, at once consumed by modern alienation and consuming the visual spectacles of the panorama Paris offers. The female *flâneur* emerges fully fledged in French cinema however. She is glimpsed in Varda's *Cléo de 5 à 7*, but really finds her place in the city and French film-making after the development of French feminism post 1968, after the achievement of Wim Wenders's *Alice in the Cities* (1974) and in new cinematic attempts to look at the city as a space of fantasy and alienation. The two examples I will take come from the 1974 and 1993 respectively; both replace the straight lovers of the *nouvelle vague* with a female couple, in each case friends, rivals and doubles.

Jacques Rivette's *Céline et Julie vont en bateau* (1974) is one of the landmarks of French art cinema. Rivette is a key director associated with the *nouvelle vague* and this affiliation is witnessed in his first feature *Paris nous appartient* (1961). Like Godard, rather than Truffaut or Chabrol, his work has remained consistently radical and exploratory. His films are often very long (*Céline et Julie* lasts three hours) and frequently depend on a meandering and associative plot. This serves Rivette's purpose perfectly in *Céline et Julie*, a film which creates a play of fantasy and magic traced across the streets of Paris. The city, a very real and visual urban space in the film, is nevertheless de-realised as it becomes a dream stage for the performance of the identities of its two female protagonists. This quality of the film is brought out in its English title: *Phantom Ladies over Paris*. The French title draws on the colloquial French expres-

sion: 'mener quelqu'un en bateau' (to take someone for a ride); this reflects the viewer's sense that she or he is being taken in by the film. This is a film of intimacy and deception.

Céline et Julie vont en bateau opens with a close up of Julie (Dominique Labourier) as she sits on a bench in a square. Like a child, she is making shapes with her sandal in a sandpit. The camera moves out from Julie to show the chestnut trees that surround the square, the façades of the buildings round about. These signifiers establish the location as Paris. The pace of the film is leisurely as it focuses on a cat stretching across a bench, and a play of sunlight. The stillness of the square is broken, though, by the arrival of Céline (Juliette Berto) who appears in trailing clothes and an emerald feather boa. She seems conjured up by Julie who is aptly reading a book on magic. Céline initiates the chase which will thread through the film and take the place of any narrative structure. She sets off through the streets, steps and hidden passages of Montmartre, dropping garments as she goes and followed, paces behind, by a loyal and loving Julie.

The space of Montmartre has many cinematic and art historical referents. For Rivette it is almost an animated Escher drawing as the camera follows the protagonists up and down changing flights of stairs. This is a real space: we see the funicular and streets below. Yet Rivette avoids the icons of Paris such as Sacré Coeur which have become cinematic clichés (although we do hear the basilica bells ring). The film concentrates on the borderline spaces of the city and makes the city a space where the difference between internal and external is denied. Here the squares in which much action takes place are significant. They are enclosed by railings, yet open, an arena. They are shadowed by trees, yet uniquely urban. The camera follows the protagonists into interior spaces too: cafés, the library where Julie works, a waxwork museum, Julie's apartment where Céline takes a shower in one of the film's signature scenes, her bare skin seen in contrast to the bright blue of the bathroom.

Finding a space for women in the city, Rivette interrelates public and private and lets the protagonists transform the space they inhabit. Céline and Julie are engaged in a play of identity which

works to shift the way film represents gender. The film theorist D.N. Rodowick discusses the film in detail in his book *The Difficulty of Difference* where he seeks to dispute the polarised reading of viewing relations we have seen proposed by Mulvey. For Rodowick, *Céline et Julie* offers different positions of identification where the active and passive roles are both played by women. He draws on comments by Rivette himself who claims that a film should work to transform the viewer, that he or she should no longer be the same after seeing *Céline et Julie*, for example. So *Céline et Julie* supposedly does not replicate fixed viewing positions, but draws the viewer into a fantasy drama where identity is unstable and the product of a series of games and spectacles. Céline and Julie literally spend much time dressing and undressing, playing each other and crossing gender boundaries.

The film has influenced various directors, notably in recent years Richard Linklater in *Before Sunrise* (1995). This film transposes the cinematic city and key location from Paris to Vienna, but offers a similar rambling and affectionate narrative. Here the protagonists are male and female, Céline (Julie Delpy) and Jesse (Ethan Hawke). Linklater supposedly imposes a gender split in retrospect in his tribute to Rivette's film. This seems to reflect the way in which Céline (Juliette Berto) is unmistakably the object of fascination for camera, viewer and Julie in the earlier film. Yet despite its return to heterosexual binaries, *Before Sunrise* itself still seeks in part to disrupt gender roles in the relations it traces between its protagonists. Notably *Céline et Julie* fights shy of overtly eroticising the relation between the two women it represents. Instead it works on the borderlines of dream and reality, with the submerged sexual symbolism and lush innocence of Lewis Carroll's *Alice in Wonderland*. Paris becomes a city of dreams and a stage for the unconscious (where Rivette animates again the Surrealist city of Breton or Aragon).

Another female couple who have inhabited cinematic Paris more recently appear in Martine Dugowson's *Mina Tannenbaum* (1993). Although Dugowson has been making films since the early 1980s, *Mina Tannenbaum* was her first to receive international

acclaim. It was followed by the less successful, though enjoyable *Portraits chinois* (1996) which adds Helena Bonham Carter to a cast of young French actors. Dugowson's real strength in both films is in depicting the intensities, and rivalries of female friendship. More so than in *Céline et Julie*, this female/female relation is set in a heterosexual and psychologically realistic representation of society. Dugowson shows the ways in which friendship is animated by similarity and difference. Her characters are seen to identify closely with one another, but in that identification comes a troubling desire to be the other, to submerge her and take on her identity (this same phenomenon is explored in more pathological terms in *Single White Female*, a film which also, incidentally, pays homage to *Céline et Julie*).

Mina Tannenbaum is in every sense a personal history and an exploration of film as a means of telling a life story. It begins after Mina's death, with a series of straight to camera testimonies about Mina from the protagonists of the film. These punctuate the titles and end with a rather nervous and high-pitched account from Mina's cousin who becomes the consciousness and agent of the narrative. These testimonies set the tone of the film which is peculiarly hybrid, at once comic, quirky and elegiac. An overblown soundtrack, mixing emotion and irony, featuring Dalida's amazingly sentimental 'Il venait d'avoir 18 ans', also works to this effect.

Mina is shown to have been an artist who has committed suicide. Her life story is traced through flashback from her childhood through the complexities of her friendship with Ethel, who gradually emerges from Mina's shadow. The film is a taut psychological drama. It is also, and more objectively, an account of a specific community in Paris and a visual exploration of the spaces of the city. Mina and Ethel are both Jewish. Dugowson offers a perspective on the urban and cultural spaces of their childhood and adolescence. The privileged Parisian space of the film is again Montmartre. The girls meet here. The steep incline of the streets in the area allows the film to open up the city in a huge vista, and to explore the girls' perspective and image from different points of view. One scene takes place on the steps in front of Sacré Coeur,

with the basilica viewed as an icon in the background. Montmartre seems to signal bohemianism, youth and freedom here. It is also the location of the bench where we see Mina and Ethel sitting together (like Céline and Julie) in one of the film's signature images. They first sit here as seven year olds, just starting to make friends, when Mina gives Ethel her painting of Gainsborough's two daughters. The bench then becomes the locus of a shift in the time frames of the film where Dugowson moves in a seamless 360° shot from an image of the little girls to an image of Mina (Romane Bohringer) and Ethel (Elsa Zylberstein) as adolescents in the same position. We see Ethel in bellbottoms and trailing scarves, Mina in a beret and clumpy shoes. The film seems to capitalise on the retro chic of the 1970s, yet also to use the outlandish fashions for humour and partial caricature. As the film moves forwards into the 1980s, it loses some of its lightness and offers a more piercing account of Mina's rise and fall in the art world, and of Ethel's reinvention. The spaces of the city change too to become more anonymous and cosmopolitan.

The friendship between the two young women is represented for the most part in public spaces: on the bench as noted above, in cafés (always a key location in Parisian filmmaking) at parties in the glitzy art world Mina briefly inhabits. Dugowson creates a dialogue between public and private where the geography of the film saves its visual narrative from over-indulgence in psychological complexities. Dugowson shows interest in image as well as emotion and here the city figures large with its instantly recognisable cream façades, slate roofs, storefronts (we see the rue des Rosiers in the Marais), monuments and soft grey light.

Mina and Ethel both in different ways have difficult relations to their families. Mina's relation with her mother, for example, is overshadowed by her mother's experience of the Holocaust. Mina is shown, unfairly but understandably, to be oppressed by her mother's survivor guilt. Ethel although closer to her mother, who is all the more controlling, is in a relationship with a gentile which she must hide from her family. Where the family is a fraught centre to the film, the city contrarily appears an intimate and indigenous

space for the two protagonists. Dugowson emphasises the ways in which Paris can be reviewed through a different gender perspective which offers a new vision of the city.

3 Boys in the City

The film which has brought urban politics and the image of the city most radically into question in French cinema in recent years is Mathieu Kassovitz's groundbreaking *La Haine* (1995). The film works on a number of levels. Most importantly perhaps it is a film of new, gritty social comment (if not realism). In this it can be seen as part of a current trend in French filmmaking which attempts to represent the experiences of the youth of the *cités* of the *banlieue* around Paris and Marseille in particular (consider Claire Denis's *Nenette et Boni*, 1996, too), and in the post-industrial and depressed North of France (for example Bruno Dumont's devastating *La Vie de Jésus*, 1997, or Erick Zonka's *La Vie rêvée des anges*, 1998). *La Haine* charts a day in the life of three late adolescents: Saïd, Vinz and Hubert. Kassovitz chooses a day of maximum emotional impact, the aftermath of riots in the *cité* where the boys live. They are waiting to know the fate of their young friend Abdel who has been brutally beaten by the police. The film replicates the tension and restlessness of this watchful hiatus. It culminates in the revelation of Abdel's death; this news brings only new senseless, nervous violence. The engaged social commentary the subject entails is counterpointed by a stylistic playfulness and stylisation which mark the film out as particularly self-conscious and as tightly focused *auteur* cinema. Comparison with Kassovitz's earlier *Métisse* (1993) only confirms the ways in which Kassovitz works to make his mark through the replication of certain traits, themes and images (as we shall see).

La Haine opens with a silent titles sequence, interrupted only by black and white news footage of a riot. This is followed by one of the film's most compelling images and the only colour shots we see: a satellite image of the world against which we hear Hubert's voice telling the story of a man who fell from a skyscraper. As he

falls past each floor the man says 'jusqu'ici tout va bien' (so far so good), but as Hubert says, 'l'important c'est pas la chute. C'est l'atterrissage' (how you fall doesn't matter. It's how you land!). We see a petrol bomb fall through the sky to explode in garish flames which fill the screen. The sound of the explosion triggers the music of the soundtrack, Bob Marley's 'Burnin' and Lootin', which plays over the rest of the opening credits sequence. This is backed by further news footage. Already we encounter the different registers of the film. Kassovitz quotes his own *Métisse* which opens with a similar image of the world, he creates a slogan for *La Haine* ('jusqu'ici tout va bien') and a brief allusive snapshot of its incendiary message. The news footage seems at odds with this more stylised, sign-saturated filmmaking, yet using black and white photography, and exploiting the vivid rhythms of the reggae soundtrack at this moment, Kassovitz contrives to work through strong contrast with the force and violence of Kubrick filming graphic action to music in *A Clockwork Orange* (1971).

The news footage is rapidly brought into focus as the music fades out, replaced by the voice-over reporting of a news broadcast. *La Haine* identifies the way it works to present a 'documentary' reality which is nevertheless self-consciously framed and highlighted as artifice. The film exploits the visual culture to which it belongs, yet it also remains wary of it. As the three protagonists are sitting in a playground in the *cité* they are accosted by a pair of journalists in a car with a video camera. The distance between the boys and the journalists is emphasised in an intervening fence. As they yell abuse at the journalists, Hubert adds that they're not in a safari park. Kassovitz seems to suggest that the filming of *La Haine* itself crosses this demarcation line and comes closer to the lived reality of the protagonists it represents. This is reflected in the behaviour of the production crew and artists who worked on the shoot in their efforts to become part of the community they were reproducing in fiction. Interviews in the magazine *Première* detail this search for authenticity. Eric Pujol, the Assistant Director, reveals that the production team contacted twelve different *cités* in the Paris *banlieue*. Eleven turned them down. The twelfth became the

location of *La Haine*: a *cité* of 7,500 inhabitants. The team rented two apartments in the *cité*, one for Kassovitz and the actors, the other for the production unit. Quickly they worked to create a rapport with the inhabitants of the *cité*. Pujol explains: 'On a mis longtemps ... à leur faire comprendre qu'on n'était pas des journalistes. Ils ont vu à la télé trop de reportages merdiques qui déforment et dramatisent leur vie' (we took a long time to explain to them that we weren't journalists. They had seen too many shitty documentaries on TV giving false impressions of their lives, p. 106).

Most of the extras for the film were hired in the *cité* itself. As for the principal actors, while Vincent Cassel and Hubert Koundé worked with Kassovitz before on *Métisse* (playing very different parts), Saïd Taghmaoui, also a professional actor, actually comes from Aulnay in the Paris *banlieue* and lived in the *cité des 4000*. All three actors have the same names as the protagonists they play. All three are personal friends of Kassovitz. Notably the director himself appears in the film as the young skin head who is beaten and threatened by Vinz (encouraged by Hubert) near the end of the film. (Kassovitz is also very successful as an actor in Jacques Audiard's *Un Héros très discret*, 1995). The appearance of the director as minor part is a cinematic in-joke since Hitchcock. In *La Haine* is takes on new resonance where the protagonists literally turn on the director, hounding him and holding him at gunpoint. This seems to reflect the near autonomy of the actors at certain points. Kassovitz points out that he himself is neither black nor *beur* (backslang or *verlan* for Arab). He's from a Jewish background instead and doesn't come from the *cités*. He films from a certain distance, but compensates for this in the authenticity of his project. As he says: 'Je crois que ni le ministère de l'intérieur ni les mômes de banlieue ne peuvent dire que ce qui est dans le film est faux' (I don't think either the minister of the interior or the kids from the *banlieue* can say that what is in the film is false, p. 111).

In filming on location, Kassovitz creates two distinct urban spaces in his film. The first, and the dominant, is the space of the

cité. This mingles real and surreal as Kassovitz disrupts an image of this living space as concrete wasteland. The space becomes an aesthetic object as Kassovitz captures its incongruous images: Michelangelo's image of the creation and a vast image of Baudelaire as stylised murals, bulbous jungle creatures in the playground, a life-size cow (seen in black and white, but product of Vinz's drug-fried mind). The black and white photography helps this impression of the *cité* as a set of shock images, with aesthetic effect. Yet Kassovitz is interested too in creating a sense of community and intimacy. The *cité* is shown as a neighbourhood: it may be violent (Abdel is brutally beaten, Hubert's gym is torched) but it is still, in Kassovitz's words, 'un milieu de village' where everyone knows each other.

This is the neighbourhood Hubert, Vinz and Saïd know and where they are at home (though Hubert in particular is desperate to leave). Kassovitz emphasises their relative freedom of movement in the *cité* and its familiarity in the film's *mise-en-scène*. In the *cité* scenes there are tracking shots and there is much moving camera work. Early in the film overhead shots from a helicopter mark out the way the film works to offer an overarching view of this space and its community, despite its specific focus on the three protagonists. The camera also follows them into their family homes, briefly establishing the familial networks which bind them, and which they escape in the US-influenced street culture that dominates the public spaces of the *cité.*

The other space of the film is Paris itself. The city becomes a space of alienation. Hubert, Vinz and Saïd travel there by RER. The film focuses on their journeys both ways, showing both the literal connection and the social and cultural separation between the city and its *banlieue.* In the city the three protagonists are immediately outsiders. Their disorientation is reflected in a virtuoso scene when the protagonists stand looking over Paris. The camera tracks backwards from the characters while zooming in on the scene behind them, creating visual disorientation and the uncanny movement of the inanimate background. Kassovitz achieves a visual inscription of the division between the protagonists and the

urban environment. They are rapidly distanced from our view-point. We see their impassivity and seeming vulnerability in the city. This is reflected as they are ejected from a chic gallery *vernissage* (private view). Here Hubert tries to pick up a young woman played by Julie Mauduech, saying she looks familiar (another glancing reference to *Métisse* where the two actors play together).

The characters' inability to make their mark in the city, their sense of being out of kilter in this space, is heightened in a scene where they look at the Tour Eiffel lit up by night. Saïd tells the others to watch while he turns off the lights. He clicks his fingers but the lights stay on. Vinz replies that it only works in movies. One reference here is Eric Rochant's appealing first feature, *Un Monde sans pitié* (1989). Here Hippo (Hippolyte Girardot) is young and drifting in Paris, relying on his drug-dealing *lycée* student brother and sharing a noisy apartment. He falls in love with Nathalie (Mireille Perrier) a brilliant student at the ENS (*École Normale Supérieure*) who is seen to be outside Hippo's league. As he seduces her with varying degrees of success the film tracks the couple through the streets of Paris, in particular around the Latin Quarter. This seems partly a visual homage to Godard and Truffaut: Mireille Perrier frequently wears red and, with her dark hair, resembles Anna Karina. When Hippo visits her apartment he takes her out onto the balcony to look over night-time Paris. The film plays on the characters' difference, where Hippo's suavity is contrasted to Nathalie's rarefied intellectualism. He is in tune with his environment and duly appears to switch off the lights of the Tour Eiffel as he clicks his fingers, to Nathalie's enchantment. *Un Monde sans pitié* is an apt point of reference for Kassovitz as he pursues an image of cinematic Paris. Class and its divisions are already an issue for Rochant, but his film works most overtly as romance about ill-assorted lovers. *La Haine* is set up in contrast to such a film, designating itself again as closer to reality. Kassovitz's characters appear to lose control of the environment around them, with none of the seeming privileges of prior filmic protagonists.

Despite its claims as more authentic filmmaking, *La Haine* operates nevertheless in a manner analogous to *A bout de souffle* towards its close, as the protagonists find the key event they wait for in fear abruptly announced in plural focus on public television screens in the city. Since they have missed the RER train back to the *cité* after being held, and brutally harassed, in police custody, they spend the night in the Les Halles complex. A vast series of screens offers silent images of news broadcasts through the night. As the protagonists watch they see the image cut from fighting in Bosnia to a sudden close-up of their friend Abdel, announcing his death. In this alienating environment they find their personal history made public news. The scene draws together the various threads that run through the film in a moment of tight focus and emotional impact. The silence of the image allows the numbness of response to be recorded.

Kassovitz's filmmaking is the antithesis of the unmediated recording of reality. He may play with documentary forms and seek authenticity in his working methods, yet his film is a complex network of aesthetic effects, cinematic allusions (Scorsese is a particularly strong influence) and hyper-realism. The film is nihilistic and anarchic in its explosive ending. It seems to cultivate rhythm and mood alone throughout, aping the very aimlessness and humour of its protagonists. Yet, surprisingly, *La Haine* works in strong social messages and at times uses Hubert in particular as a new force of conscience and consciousness. In this it seems sometimes heavy-handed on several viewings as the deliberate effects of the film become more and more apparent. This does not alter the film's impact, however, and its importance as a record and image of disaffected youth. This is a film which makes the viewer see how far the mapping of the urban involves social and cultural segregation. As Keith Reader argues, the film is important as it finds its place in a new cinema of the *banlieue*. Urban alienation may not be a new subject, but it is given new verve and vibrancy under Kassovitz's direction. The cinephile city, the city of light illumined in the *nouvelle vague*, is revealed in the 1990s as space of exclusion and dispossession.

Selected Reading

Jean-Jacques Bernard, 'Les Enfants de *La Haine*', *Première* (June 1995), pp. 104-113.

Griselda Pollock, *Vision and Difference: Femininity, Feminism and the Histories of Art* (London: 1988). See 'Modernity and the Spaces of Femininity' (pp. 50-90) for a discussion of nineteenth-century women's relation to the city.

Christopher Prendergast, *Paris and the Nineteenth Century* (Oxford, 1992). This study offers an extraordinary insight into the transformations of the French capital in the nineteenth century and the ways in which these are reflected and reviewed in the art and literature of the period.

Keith Reader, 'After the Riot', *Sight and Sound*, vol. 5, no. 11 (November 1995), pp. 12-14.

D.N. Rodowick, *The Difficulty of Difference* (New York, 1991). This theoretical discussion of spectatorship offers revelatory analysis of *Céline et Julie vont en bateau*.

Films

Chacun cherche son chat: Cahiers du cinéma, no. 501 (April 1996), p. 74; *Sight and Sound*, vol. 6, no. 11 (November 1996), p. 62.

Céline et Julie vont en bateau: Monthly Film Bulletin, no. 511 (August 1976), pp. 163-164.

Mina Tannenbaum: Cahiers du cinéma, no. 478 (April 1994), p. 75; *Sight and Sound*, vol. 4, no. 11 (October 1994), pp. 49-50.

La Haine: Cahiers du cinéma, no. 492 (June 1995), pp. 32-39; *Sight and Sound*, vol. 5, no. 11 (November 1995), pp. 12-14, 43.

8

Conclusion: Histories of Cinema

To bring this study to a close, I have chosen to look at Jean-Luc Godard's *Histoire(s) du cinéma*, a vast documentary project which casts new light on many of the issues examined here. I have already looked in some detail at Godard's first feature, *A bout de souffle*, in Chapter 4. From this début, his work continues to unfold and evolve, frequently questioning its own bases and finding new ways of making histories and stories in images. One constant seems to be a fascination with images of women, another is with consumerism and the commercialisation of the image. *Le Mépris* (1963) makes filming itself its subject, while also allowing Godard to deconstruct the image of Brigitte Bardot. *Pierrot le fou* (1965), perhaps one of Godard's finest, most driven, playful and elegiac films, is an allusive road movie, starring Belmondo and Karina. After May 68, Godard transforms his focus once more, embarking on a period of politically militant filmmaking and collaborative work. He returns to a renewed form of narrative cinema in *Sauve qui peut la vie* (1980) and *Je vous salue Marie* (1984). As Michael Temple puts it: 'Conventional wisdom has it that Godard loses the plot somewhere in the late 80s' (p. 21). His films certainly become more rarefied and demanding in the 1980s and 1990s, and more dependent on a viewer familiar with Godard's interrogative and deconstructive style. Yet, as Temple points out, this same period has marked the gradual and largely unnoticed elaboration of *Histoire(s) du cinéma*. Temple is convinced, as I am, that this is a major work. It may make us look at Godard again, and also, and all the more importantly, at the history and stories of cinema and at how these may be reviewed.

Godard's *Histoire(s) du cinéma* (1988-1997), now complete, is

made up of eight parts: 1A. *Toutes les histoires* (1988/89), 1B. *Une histoire seule* (1988/89), 2A. *Seul le cinéma* (1993/94), 2B. *Fatale beauté* (1993/94), 3A. *La Monnaie de l'absolu/La Réponse des ténèbres* (1995), 3B. *Montage, mon beau souci/Une vague nouvelle* (1995), 4A. *Le Contrôle de l'univers* (1997) and 4B. *Les Signes parmi nous* (1997). In this discussion I shall refer particularly to the first part, because it works most effectively to question and to problematise the notion of *histoire(s) du cinéma.* (Note that in including the 's' in brackets, Godard keeps the term open, allowing it to signify both stories and history). The first two parts of the project have been broadcast by Canal+ and also by Channel 4 and have thus known a wider audience than the work as a whole.

Toutes les histoires sets the rhythm of the project. Far from offering a chronological account of the history and story of cinema, Godard works instead on a type of memory project which works to trace and record the mental images and sounds cinema has left. The texture of the work is both multilayered and dissociative. Godard works to bombard the viewer with visual, verbal and auditory information. Images return to the screen from time to time, interrupting one another and interconnecting in a way which mimics mental process. One risk of this method, despite its evocative brilliance, is its very elitism. While the titles of films are frequently named in the intertitles and spoken commentary of the film, there is rarely a relation between the stills and clips we see and the films named in any one section of the project. Titles work instead to provide a series of totem words and recurring signs. *Toutes les histoires* is most powerful for the viewer, I think, in moments of recognition, where we hear or see a sound or image that we know or even just barely remember. Godard offers us no pedagogical frame in which to fix these traces and little access to his film, beyond the level of pure aesthetic pleasure in the virtuosity of his editing and interconnections. However Gallimard has now published a wonderful visual document of the series of films in the form of four volumes of stills and commentary. Appended to this is a list of the films which appear in each part, enabling the uninitiated viewer to begin to find his or her way more easily.

Toutes les histoires begins, then, with an image from *Pierrot le fou.*
Godard instantaneously locates his project in his own filmmaking
and its seductive primary colours in particular (much of the
Histoire(s) du cinéma plays with strong, vital and contrasted colours,
interspersing and overlaying filmic and art historical images).
Godard moves to an image from *Rear Window* and thus designates
the self-reflexivity of his project: Hitchcock's film is a classic explo-
ration of the proximity between voyeurism and film art. Gradually
the viewer comes to see the ways in which Godard's project as a
whole is made up of multiple fragments which carry different
meanings. From the start we see footage of the director himself
too, typing at an electric typewriter and framed against a back-
ground of books. Godard is heard to speak the words he types. We
also hear the mechanical rhythm of the type-writer and see super-
imposed words and intertitles appearing on screen. Godard places
his project between mechanical reproduction and a heightened lit-
erary auteurism. We see the director working, as the film itself
seems like work in progress. Godard takes the history of cinema to
pieces and puts it back together in a different order: his will be a
deconstructive history, an auteurist history deeply embedded in his
own concerns, and yet a history that reminds us that films them-
selves are what count and not the director who created them.

The title of the first film, *Toutes les histoires* is explained, or
echoed, close to its opening. The film will include: 'Toutes les his-
toires qu'il y aurait' (all the histories and stories that might be).
This remark is edited, repeated and reinscribed: this will also
include all the histories and stories that there will be, and all the
histories that there have been. Godard's project is at once virtual
as well as literal: he is concerned, as his use of tenses suggests, with
imagining cinema as much as recording it. His history and story
must necessarily be prospective as well as retrospective. The viewer
has a sense that the film generates images as much as commemo-
rating them. Godard is concerned with the transformative power
of filmmaking (as well as its documentary capacity as we shall see
below). A slowly evolving intertitle dominates this part of the film,
as Godard claims to quote Bazin: 'Le cinéma substitue à notre

regard un monde qui s'accorde à nos désirs' (Cinema substitutes before our eyes a world that accords with our desires). Cinema here is seen to be a personal history for the spectator who finds and traces his or her subjective image in the films he or she sees projected. Despite its photographic and realist origins (which Godard stresses here through reference to the Lumière brothers), film is seen to be infected and inflected by subjectivity and desire.

Toutes les histoires works to focus our attention on the very signs which function to give meaning in cinema. Godard does this partly by rupturing the surface illusion of film and seeking discontinuity. He will let films inhabit one another to create plural effects. As we see the words quoted above about cinema and desire appear on screen, images from *The Band Wagon* (1953), *La Règle du jeu* (1939), *The Crucified Lovers* (1954) and *Rancho Notorious* (1952) are variously intercut. Against this collage, brilliantly, we hear words from the soundtrack of *L'Année dernière à Marienbad*. The words take the form of a man's attempt to describe his memories to a woman, to trigger in her recognition of the past by which he is haunted. Memorial process and its doubtful transmission is the subject of Resnais's film: its soundtrack has its own autonomous rhythm and cadence which brings to Godard's film an insistent, familiar echo, and a new voice-over through which to view the images which appear. The soundtrack, whilst being an extract from a film, also works to comment on the mental and memorial process of the viewer as he or she watches *Toutes les histoires*.

Toutes les histoires depends thus on a process of sorting and reassortment. Godard names the masterpieces which surface first in his history of cinema: Renoir's *La Règle du jeu* (The Rules of the Game) and Bergman's *Cries and Whispers* (these titles work too as seeming descriptions of Godard's own project). In the course of the film he also names the literary and theoretical texts with which he appears to seek and find affinity: Bergson's writings on subjective memory in *Matière et mémoire*, the interlayered narratives of *Les Mille et une nuits*, the self-reflexivity of Gide's *Les Faux-monnayeurs*. Godard's project establishes links between a modernist literary tradition and his own work, as he also brings back visual echoes from

nineteenth-century and earlier art. Yet the dominant themes of *Toutes les histoires* nevertheless relate specifically to cinema as art form. On the one hand Godard explores the allure and menace of Hollywood as dream factory: his project stresses the commodification of art. On the other he returns to film as 'documentary' form, presenting '['l']actualité de l'histoire' (Newsreel of history) and '['l']histoire de l'actualité' (history of Newsreel). He cites literal documentary images, in particular charting the rise and fall of Fascism. The embedded relation between the development of cinema as art form and the history of the twentieth century comes very much to the fore in the study. Stills and clips from *The Battleship Potemkin* (1925) also seem to commemorate film's capacity to generate historical meanings and images through artistic means.

The canon of films on which Godard draws is very broad. Evidently his aim in telling *toutes les histoires* is to move beyond French cinema alone (although Michael Temple reminds us 'for Godard the cinema has always been necessarily a very French affair, especially in terms of its invention and theorisation'). In *Toutes les histoires* Godard barely cites the films of the 1950s on in France that have been my subject here (bar the allusions to *Pierrot le fou* and *L'Année dernière à Marienbad* noted above). He explores *nouvelle vague* cinema more closely in 3B. *Montage, mon souci/Une vague nouvelle*, which offers the viewer, amongst much else, specific focus on the iconic images of Antoine Doinel from the end of *Les 400 coups*. *Toutes les histoires* focuses rather an the *auteur* directors whose work precedes the *nouvelle vague* and who have produced images which have changed the medium from within. As I have noted, Jean Renoir's work *La Règle du jeu* is named at the very inception of Godard's project. Images of the famous rabbit chase from the film run through part of *Toutes les histoires*: we see the sheer brilliance of the images and their sense of threat and historical percipience (coming in 1939). Truffaut and Orson Welles have both described Renoir as 'the greatest filmmaker in the world'. His major French language work lies outside the period I'm treating here buts its influence is still very strongly felt.

In addition to Renoir, Godard alludes also to the work of Jean Vigo and of Robert Bresson. Vigo, a filmmaker of the 1930s, offers, in Ginette Vincendeau's words, a 'model of an *auteur* struggling against adversity'. *Toutes les histoires* closes in on images of the actress Dita Parlo in Vigo's *L'Atalante* (1934). Her expressive face fills the screen bringing with it Vigo's poetic realism and creating a real icon of early French cinema. For Godard, the more recent director, Bresson, is of importance perhaps in his quest for a 'pure' cinema, a cinema which works in every way to question, refine and reform the properties of its own medium.

Toutes les histoires revisits and re-imagines film as art form. Its history is not chronological. It is a history which privileges association, visual and mnemonic instead of temporal images. It inspires the possibility of thinking cinema differently. It is a personal history, indelibly imprinted with Godard's visual style, yet it is also a public history, a history of the art form which has changed the twentieth century and fixed its passage in images.

French cinema since 1950 works more generally to trace the relation between personal and public, revealing the ways in which cinematic images can commemorate and transform life histories and mass events. These images become part of a shared imaginary world, gaining new meanings and giving new, vicarious pleasures in viewing. Despite the intellectualism of his project, Godard conveys perhaps above all, perhaps against himself, the very exhilaration of cinema as a moving visual form. Its histories and stories can never be fixed, are always in motion and evolution.

Films live on in our minds, part of our own personal histories. This offers us a new perspective on spectatorship and how we think about film-viewing. When Michael Temple writes about Godard's *Histoires du cinéma*, he offers us insight into his literal experience of viewing the series of films for the first time. He relates an anecdote about attending the British premiere at the French Institute in London, taking the reader into his excitement about Godard and his mixed responses. Increasingly, critics and historians of film acknowledge that the conditions of viewing and the very emotions of our responses need to be taken into account in developing film

analysis. While our viewing experience may be inflected by a number of ideological factors (our gender, sexuality, race, nationality, class, age ...) all these also intersect with issues which are even less easy to consider theoretically (personality and the personal resonances of particular film images and scenes in our own life histories). Catching something of the complexity of personal response is a particular challenge to a writer on film.

For any one of the films discussed here I could offer something like a confessional narrative of how I first saw it, and what it means in my own life history. Avoiding this I want, nevertheless, to finish on a personal note and to look finally at the image which is stilled on the cover of this book. I first saw *Jules et Jim* (1961) as an A level student, when our teacher was introducing us to Truffaut. The film did not appeal to me especially at the time. It only came to mean something for me later, on several reviewings. I remember first really enjoying the film with a friend in one of the small cinemas on the Left Bank in Paris (*Les 3 Luxembourg*). We went for a drink afterwards, and all the time we were talking about the film I remember its music going round in my mind, and the speed of its image of Jeanne Moreau dropping, weightless, into the river. Memories of the moments of viewing the film, and of the film itself, began to infect one another.

Jules et Jim is a personal history, like many of the films explored in this study. It is a literary adaptation (of a novel by Henri-Pierre Roche) and a historical drama (set before the First World War in Paris). Above and beyond this, it is an intoxicating example of *auteur* cinema, where Truffaut seems as in love with the possibilities of the medium, as he is with his protagonists. The relations between the three protagonists of the film are themselves arresting. The spectator may be seduced by the easy exchange of Catherine between Jules and Jim, a triangular love revisited more recently in Marion Vernoux's *Love Etc.* (1996) and Andrew Fleming's *Threesome* (1994). The film feeds into a modern interest in gender ambiguity. The figure of Catherine herself, feverish, seductive and destructive, is emblematic of femininity and its deconstruction in French cinema. *Jules et Jim* plays between life,

death and sexuality. It is, finally, a memory piece, directed by voice-over in the past tense, where Truffaut tests the capacity of film to narrate a past history in retrospect, demonstrating the intertwining of separate destinies. Its totem song, 'Le Tourbillon', sung by Jeanne Moreau, is a song about memory, about losing and finding love. The tone of the film is at once elegiac and exhilarating. Here it may mesh with the viewer's personal history, as its impressions are reviewed in his or her mind and its past images made present once more. This is perhaps the ultimate interest of the films I've discussed as personal histories in this study.

Film-viewing is a way to access and review cinema's memories, the visual traces with which this art form has indelibly marked the twentieth century. Yet it is also a way for viewers to re-focus responses and emotions, making images into memories and creating new personal histories.

Selected Reading

Michael Temple, 'It will be worth it', *Sight and Sound* (January 1998), pp. 20-23. A very readable article which offers an invaluable account of Godard's achievement in *Histoire(s) du cinéma.*

Jean-Luc Godard, *Histoire(s) du cinéma* (Paris, 1998). Four sumptuous illustrated volumes which offer the complete text of this series of films, together with a very large number of stills.

Laura Mulvey, *Fetishism and Curiosity* (London, 1996). In this stunning volume, see particularly 'The Hole and the Zero: Godard's Visions of Femininity', pp. 77-94, for a fascinating reappraisal of Godard.

Kaja Silverman and Harun Farocki, *Speaking about Godard* (New York, 1998). An experimental and engaging series of dialogues about Godard.

Glossary

Film Terms

animation: a process by which artificial movement is created by photographing a series of drawings or objects.

auteur: the presumed or actual 'author' of a film, usually identified as the director.

cinéma vérité: a new approach to documentary filmmaking, developed in the 1950s and 1960s. Filmmakers used portable cameras and synchronised-sound recording equipment to present a more spontaneous and objective view of events.

cinematography: a general term for all the manipulations of the film strip by the camera in the shooting phase and by the laboratory in the developing phase.

close-up: a framing in which the scale of the object shown is relatively large; most commonly a person's head seen from the neck up.

cut: in the finished film, an instantaneous change from one framing to another.

diegesis: in a narrative film, the world of the film's story.

editing: in filmmaking, the task of selecting and joining camera takes. In the finished film, the set of techniques that governs the relations between shots.

establishing shots: shots which show the spatial relations among the important figures, objects and setting of a scene; often used to establish the geographical location of a particular scene.

femme fatale: the heroine of *film noir*, often a powerful, seductive and deadly woman.

film noir: a term applied by French critics to a type of American film, usually in the detective or thriller genres, with low-key lighting and a sombre mood.

flashback: an alteration of story order in which the plot moves back to show events that have taken place earlier.

frame: a single image on the strip of film.

framing: the use of the edges of the film frame to select and to compose what will be visible onscreen.

genres: various types of film which audiences and filmmakers recognise by their familiar narrative conventions. Common genres are musical, comedy and thriller.

hand-held camera: the use of the camera operator's body as a camera support, either holding it by hand or using a harness.

jump cut: a cut that appears to be an interruption of a single shot so that the image on screen seems to jump; such an effect is created when there is little change between two shots edited in sequence.

long shot: a framing in which the scale of the object is small, as if viewed from a distance.

mise-en-scène: all the elements placed in front of the camera to be photographed: the settings and props, lighting, costumes and make-up, and figure behaviour.

montage: a synonym for editing. Used specifically to refer to an approach to editing developed by Soviet filmmakers of the 1920s; it emphasises dynamic, often discontinuous, relationships between shots and the juxtaposition of images.

rushes: prints of takes that are made immediately after a day's shooting so that they can be examined before the next day's shooting begins.

shot: in shooting, one uninterrupted run of the camera (also called a take). In the finished film, one uninterrupted image with a single static or mobile framing.

shot/reverse shot: two or more shots edited together that alternate characters, typically in a conversation situation.

tracking shot: a mobile framing where the camera travels through space either forward, backward or laterally.

voice-over: the narrator or protagonist's voice heard when he or she is not seen.

zoetrope: an early antecedent of cinema consisting of a cylinder with a series of illustrations or photographs on the interior and regularly spaced slits through which the viewer observes the images in sequence.

zoom lens: a lens with a focal length that can be changed during a shot, giving an impression of artificial or accelerated movement.

Directors, Writers and Actors

Louis Aragon (1897-1982): surealist novelist, most renowned for his experimental work, *Le Paysan de Paris*, a dream-like exploration of the arcades and parks of Paris.

Antonin Artaud (1896-1948): dramatist, theorist and actor (in Dreyer's *La Passion de Jeanne d'Arc*, 1928). Artaud wrote an extremely influential series of essays, collected as *Le Théâtre et son double*, which radically transformed twentieth-century theatre.

Olivier Assayas (1955-): former critic at *Cahiers du cinéma*. Director of *Irma Vep* (1996) amongst other films.

Jacques Audiard (1950-): screenwriter and director of *Un héros très discret* (1996), a film which offers a different take on the war years.

Jacqueline Audry (1908-1977): an early woman director in French cinema. Most famous for her adaptation of Dorothy Bussy's novel, *Olivia* (1951).

Daniel Auteuil (1950-): French actor who first really made his mark in *Jean de Florette* (1986) and *Manon des sources* (1986). He has since starred in *Romuald et Juliette* (1989), *Un Coeur en hiver* (1993) and *La Reine Margot* (1994) amongst many other films.

Josiane Balasko (1951-): director and actress. First trained in *café-théâtre* and then moved into film work, notably playing a major part in Bertrand Blier's *Trop belle pour toi* (1989). As a director, she has known considerable success with her lesbian comedy, *Gazon maudit* (1995).

Honoré de Balzac (1799-1850): Realist novelist who offers an analysis of different strata of French society in his *Comédie humaine*. Most famous amongst his novels are *Le Père Goriot*, *Illusions perdues* and *La Cousine Bette*.

Brigitte Bardot (1934-). French actress, famed in the 1950s and 1960s for her blonde, sex-kitten image. She stars notably in Roger Vadim's *Et Dieu créa la femme* (1956) and Godard's *Le Mépris* (1963).

Roland Barthes (1915-1980): theorist and critic, whose works 'La Mort de l'auteur' and *Le Plaisir du texte* introduced the notion of the death of the author. Barthes's later writing focuses in novel ways on questions of

autobiography, desire and photography. Most remarkable are: *Roland Barthes par Roland Barthes*, *Fragments d'un discours amoureux* and *La Chambre claire*.

André Bazin (1918-1958): French film critic and theorist, particularly influential in his writing for *Cahiers du cinéma*.

Simone de Beauvoir (1908-1986): novelist, feminist and philosopher; author of the vastly influential two volume work, *Le Deuxième sexe*.

Jean-Jacques Beineix (1946-): director whose work typifies the *cinéma du look*. He knew a huge success with *Diva* (1980). This was followed by *37°2 le matin* (1986). Both have become cult films, where others of his films have been far less successful.

Jean-Paul Belmondo (1933-): French actor whose image, since his starring role in *A bout de souffle* (1959), has become associated with the *nouvelle vague*. Belmondo also stars in *Une Femme est une femme* (1961) and *Pierrot le fou* (1965) amongst many other films.

Claude Berri (1934-): French director who has gained world acclaim for his works, *Jean de Florette* (1986) and *Manon des sources* (1986). He has also played an important role as producer of films such as *L'Amant* (1991), *La Reine Margot* (1994) and *Gazon maudit* (1995).

Luc Besson (1959-): director whose work is associated with the *cinéma du look* which came to the fore in the 1980s. Besson's first successes were with *Subway* (1985) and *Le Grand Bleu* (1986). Although he proves his worth in French cinema in *Nikita* (1990), increasingly he is working in the US, making English language features such as *Léon* (1994) and *The Fifth Element* (1997).

Juliette Binoche (1964-): French actress who first starred in Téchiné's *Rendez-vous* (1985). She went on to represent an icon of the *cinéma du look* in Léos Carax's *Mauvais sang* (1986) and *Les Amants du Pont Neuf* (1991). More recently she has starred in a range of roles which capitalise on her calm and equanimity: *Trois couleurs: bleu* (1993), *Le Hussard sur le toit* (1995) and *Alice et Martin* (1998).

Bertrand Blier (1939-): director who has specialised in quirky, shocking comedy. His films include *Les Valseuses* (1973), *Tenue de soirée* (1986), *Trop belle pour toi* (1989) and *Mon homme* (1996).

Robert Bresson (1901-): a highly original and important *auteur* who has consistently approached questions of spirituality in his films. His most celebrated works include, *Le Journal d'un curé de campagne* (1951), *Un Condamné à mort s'est échappé* (1956), *Pickpocket* (1959) and *L'Argent* (1983).

André Breton (1896-1966): surealist poet and novelist, author of the *Manifestes du surréalisme*. Breton's autobiographical novel, *Nadja*, replaces conventional description with photographs, fusing the boundaries between the real and the imaginary.

Léos Carax (1960-): one of the most critically popular directors of the *cinéma du look*. Carax's first features *Boy Meets Girl* (1984) and *Mauvais sang* (1986) caused him to be hailed as a prodigy. *Mauvais sang* is an extraordinary, hallucinatory work, making brilliant use of primary colours and cinematic allusions. His next film, *Les Amants du Pont Neuf* (1991) ran into vast financial and production difficulties, though the final film is still visually and emotionally arresting.

Marcel Carné (1906-1996): director who was the foremost exponent of Poetic Realism. Carné's most memorable films are *Hôtel du Nord* (1938), *Quai des brumes* (1938), *Le Jour se lève* (1939), *Les Visiteurs du soir* (1942) and *Les Enfants du paradis* (1943-45).

Claude Chabrol (1930-): director whose first works, *Le Beau Serge* (1957) and *Les Cousins* (1958) are seen in many ways to have inaugurated the *nouvelle vague*. Latterly he has made his mark with sharply judged psychological thrillers from *Le Boucher* (1970) through to *La Cérémonie* (1995). *Madame Bovary* (1991) also amply demonstrates his success in the heritage genre.

René Clément (1913-1996): a director associated with the 'tradition de la qualité', whose most celebrated film is *Les Jeux interdits* (1952).

Henri-Georges Clouzot (1907-1977): French post-war director who has done much to develop a French *noir* tradition, in particular in *Quai des Orfèvres* (1947) and *Les Diaboliques* (1955).

Jean Cocteau (1889-1963): idiosyncratic French director, novelist and artist. His early surrealist film, *Le Sang d'un poète* (1930), was followed by cinematic explorations of myth and fairytale in *La Belle et la bête* (1946), *Orphée* (1949) and *Le Testament d'Orphée* (1960).

Colette (1873-1954): woman writer whose works combine fiction and autobiography, heady sensuality and limpid prose. Her first published works are the *Claudine* novels; other works include *Le Blé en herbe* (filmed by Claude Autant-Lara in 1953), *Chéri* and *La Fin de Chéri*.

Cyril Collard (1958-1992): writer and director of *Les Nuits fauves*, an extremely successful film about AIDS, *amour fou* and filmmaking.

Alain Corneau (1943-): a director most noted for his heritage movies in the 1980s and 1990s, although previously he made a number of

thrillers. His greatest success has been *Tous les matins du monde* (1991).

Constantin Costa-Gavras (1933-): French director of Greek origin, most celebrated for his political thrillers.

Raoul Coutard (1924-): French cinematographer, well known for his *nouvelle vague* work, particularly with Godard on *A bout de souffle* (1959).

Jacques Demy (1931-1990): director of highly personal and well-loved films, including *Lola* (1961), a wonderful film about a cabaret artist in Nantes, *Les Parapluies de Cherbourg* (1964), a musical starring Catherine Deneuve, and *Peau d'âne* (1970), a cinematic adaptation of the Perrault fairy tale.

Catherine Deneuve (1943-): an actress who is now an icon for France and for femininity. Her wide range of roles, and cinematic successes, stretch from Luis Buñuel's *Belle de jour* (1967) to Truffaut's *Le Dernier métro* (1980) and Téchiné's *Les Voleurs* (1996).

Gérard Depardieu (1948-): French actor who has proved the biggest star in French cinema since the 1970s. His image combines rough masculinity and a certain appealing sensitivity. He has drawn large audiences in his work in the heritage genre in the 1980s and 1990s. His work is stunning in different ways in earlier films of a very different genre such as Blier's *Les Valseuses* (1973) and Pialat's *Loulou* (1979).

Arnaud Desplechin (1960-): director whose third feature, *Comment je me suis disputé (ma vie sexuelle)* (1996), an examination of sexual mores amongst young intellectuals in Paris, has known critical success.

Martine Dugowson (no dates available): woman director, most notably of *Mina Tannenbaum* (1994) and *Portraits chinois* (1996). Particularly notable for her explorations of female friendship.

Germaine Dulac (1882-1942): early woman director of *La Souriante Mme Beudet* (1923), a portrayal of the life of a bourgeois housewife and *La Coquille et le clergyman* (1928), made from a script by Artaud and offering extraordinary dream images.

Bruno Dumont (1958-): young director whose film, *La Vie de Jésus*, explores social issues with hard-hitting realism.

Marguerite Duras (1914-1996): novelist, director and screenwriter. Her novels include *Moderato Cantabile* (1958), *Le Ravissement de Lol V. Stein* (1964) and *L'Amant* (1985). She directed *India Song* amongst other films, and wrote the screenplay for Resnais's *Hiroshima mon amour* (1959).

Louis Feuillade (1873-1925): a pioneer of French cinema, who made two immensely popular series of crime films: *Fantômas* (1913-14) and *Les Vampires* (1915-16).

Gustave Flaubert (1821-1880): nineteenth-century novelist, most celebrated for his creation of a fallible and seductive anti-heroine in his novel *Madame Bovary*.

André Gide (1869-1951): early twentieth-century novelist who wrote a series of short *récits* which explore themes of morality, spirituality and desire. Gide's one novel, *Les Faux-monnayeurs*, is an innovative and self-reflexive exploration of the novel form itself, focusing on a fictional writer.

Jean-Luc Godard (1930-): perhaps the most radical and influential director of the *nouvelle vague*, Godard has continued to question and refine cinema as art form, exploring genre, gender and consumerism. His early films, for example, *A bout de souffle* (1959), *Une Femme est une femme* (1961), *Le Mépris* (1963), *Pierrot le fou* (1965), are the most accessible. After developing an extreme counter cinema in the years after 1968, Godard returned to narrative film in the 1980s with *Sauve qui peut la vie* (1980) and *Je vous salue, Marie* (1984), amongst other films. His most important late work will probably prove to be his vast documentary project, *Histoire(s) du cinéma*.

Philippe Harel (1955-): director of *Les Randonneurs* (1997) a sharp comedy about hiking in Corsica, and the wonderful, experimental *La Femme défendue* (1997), a film about a man having an affair, played by Harel himself, and shot entirely from his point of view.

Isabelle Huppert (1955-): celebrated actress who has starred in many films, including *Coup de foudre* (1983) and *Madame Bovary* (1991). She is also notable playing a nun turned pornographer in Hal Hartley's *Amateur* (1994).

Cédric Kahn (1967-): young director whose film, *Trop de bonheur* (1994) was part of the series *Tous les garçons et les filles de leur âge*.

Anna Karina (1940-): actress of Danish descent who is most famous for her work with Godard in films such as *Vivre sa vie* (1962) and *Pierrot le fou* (1965). Karina represented a new image of women in the *nouvelle vague*.

Mathieu Kassovitz (1967-): celebrated young director of *Métisse* (1993) and *La Haine* (1995). His films display a strong visual style and a dramatic new representation of urban spaces and social issues.

Krzysztof Kieślowski (1941-1996): Polish director whose last four films, *La Double vie de Véronique* (1991) and the *Trois Couleurs* trilogy (1993-1994) were made partly in French. Kieślowski is associated with themes of chance, faith and spirituality. His later films are visually sumptuous, using colour filters and many internal reflections within the frame.

Cédric Klapisch (1961-): director of *Chacun cherche son chat* (1996) and the comedy *Un Air de famille* (1997) (in collaboration with the French comedy writers and actors Jean-Pierre Baccri and Agnès Jaoui, who have starred more recently in Alain Resnais's *On connaît la chanson*, 1998).

Diane Kurys (1948-): woman director whose films frequently explore autobiographical and retro themes. Her work includes *Diabolo menthe* (1977), *Coup de foudre* (1983) and *La Baule-les Pins* (1990).

Jean de La Fontaine (1621-1695): poet and fabulist, renowned for his *Fables* (first published 1668), drawn from such sources as Aesop and Phaedrus, but written in verse and constituting a commentary on his own age.

Pascal Lainé (1942-): novelist who is most widely known as the author of *La Dentellière*.

Claude Lanzmann (1925-): documentary filmmaker whose vast work, *Shoah* (1985), remains an unequalled testimonial document to the horror of the Holocaust.

Jean-Pierre Léaud (1944-): actor who is closely associated with the *nouvelle vague*. He plays Antoine Doinel in Truffaut's series of films.

Louis Malle (1932-1995): one of the key directors of the *nouvelle vague* and beyond. Malle has developed several strong themes in his work. *Lacombe Lucien* (1974) and *Au revoir les enfants* (1987) explore the Occupation in personal terms. More generally, from *Les Amants* (1958), through to *Milou en mai* (1990), Malle has explored French sexuality and social mores.

Chris Marker (1921-): experimental French filmmaker whose groundbreaking, *La Jetée* (1964), almost entirely made up of still photographs, offers a visual meditation on memory, loss and the future.

Jean-Pierre Melville (1917-1973): independent filmmaker, most noted for his bleak thrillers, in particular the remarkable and stylised film, *Le Samouraï* (1967), starring Alain Delon.

Miou-Miou (1950-): French actress who first worked in *café-théâtre*. She is

particularly associated with the films of Bertrand Blier, starring, for example, in *Tenue de soirée* (1986). She is striking in *Coup de foudre* (1983). More recently she has known great popular success playing La Maheude against Depardieu's Maheu in Claude Berri's *Germinal* (1993).

Patrick Modiano (1947-): novelist whose work contends with questions of memory and amnesia. Modiano has frequently taken the years of the Occupation and the aftermath of the war as his subject in novels such as *Les Boulevards de ceinture* and *La Place de l'Etoile*. He wrote the screenplay for Louis Malle's film about a collaborator in the Second World War, *Lacombe Lucien* (1974).

Yves Montand (1921-1991): popular actor since the 1940s who crowned his career with his immense success playing César in *Jean de Florette* (1986) and *Manon des sources* (1986).

Jeanne Moreau (1928-): actress whose image became closely associated with the *nouvelle vague*. Moreau first starred in Louis Malle's *Ascenseur pour l'échafaud* (1957) as a French *noir* femme fatale and in *Les Amants* (1958) as an adulterous aristocrat. Her sensuality and energy are found at their most perfect in *Jules et Jim* (1961). Moreau continues to represent French femininity in a range of international productions.

Marcel Ophuls (1927-): director of *Le Chagrin et la pitié* (1969), a film which uses personal testimonies and documentary techniques, questioning France's role in the war.

Marcel Pagnol (1895-1974): immensely popular novelist and director who is particularly associated with Provence where much of his work is set. As a filmmaker he gained popular acclaim with his trilogy, *Marius* (1931), *Fanny* (1932) and *César* (1936). He is most well-known nowadays for his autobiographical work, which inspired the films *La Gloire de mon père* (1990) and *Le Château de ma mère* (1990), and for his late two-part novel, *L'Eau des collines*, which was adapted for cinema by Claude Berri in *Jean de Florette* (1986) and *Manon des sources* (1986).

Blaise Pascal (1623-1662): highly influential seventeenth-century writer, best known for the unfinished *Pensées* (published posthumously in 1670), which constitutes a defense of the Christian religion.

Maurice Pialat (1925-): director whose work is typified by a bleak, engaged realism, witnessed in films such as *Loulou* (1979) and *A nos amours* (1983). He offered a new take on period drama in *Van Gogh* (1991).

Pascal Quignard (1948-): contemporary novelist, author of *Tous les matins du monde.*

Jean-Paul Rappeneau (1932-): director who has known great success in the heritage genre, notably with *Cyrano de Bergerac* (1990) and *Le Hussard sur le toit* (1995).

Jean Renoir (1894-1979): one of the greatest French directors. Renoir's most celebrated films offer a blend of realism and a certain sensory and poetic sensibility, as witnessed in *Une Partie de campagne* (1936), the pacifist *La Grande Illusion* (1937) and the extraordinary critique of the aristocracy, *La Règle du jeu* (1939).

Alain Resnais (1922-): celebrated director who first worked in documentary, making films such as *Nuit et brouillard* (1955) and *Toute la mémoire du monde* (1956), he went on to make the groundbreaking *Hiroshima mon amour* (1959) and *L'Année dernière à Marienbad* (1961), both of which transform the representation of memory, trauma and fantasy in French cinema. These have been fairly constant themes in Resnais's later work. More recently he has known a surprising popular success in France with his musical comedy *On connaît la chanson* (1998).

Jacques Rivette (1928-): a central and idiosyncratic filmmaker of the *nouvelle vague*, who worked as a critic for *Cahiers du cinéma.* Perhaps Rivette's most memorable film is the famous *Céline et Julie vont en bateau* (1973). More recently he has explored themes of art and history in *La Belle Noiseuse* (1991) and *Jeanne la pucelle* (1994).

Eric Rochant (1961-): young director whose first feature film, *Un Monde sans pitié* (1989), was received with much acclaim.

Eric Rohmer (1920-): one of the most prolific and constant of the *nouvelle vague* filmmakers. Rohmer's films combine a philosophical exploration of morality and chance, with a concern for sensuality and visual beauty. He first knew international success with *Ma Nuit chez Maud* (1968). This was followed by several important series of films: *Contes moraux* (1962-72), *Comédies et proverbes* (1980-87) and *Contes des quatre saisons* (1989-98).

Jean Rouch (1917-): ethnographer turned documentary filmmaker. Rouch's work had a strong influence on the development of the *nouvelle vague.*

Claude Sautet (1924-): a director whose films are typified by sober, intimate realism. His work was little known outside France until the success of *Un Coeur en hiver* (1993), a film about repression, desire and

classical music. It stars Emmanuelle Béart, as does Sautet's next box-office success, *Nelly et Monsieur Arnaud* (1995).

Coline Serreau (1947-): woman director who has been highly successful in developing French comedy. Her most successful and popular works are *Trois hommes et un couffin* (1985) and *Romuald et Juliette* (1989) Her later film, *La Crise* (1992), is a comic tale of a man's mid-life crisis.

Stendhal (Henri Beyle) (1783-1842): nineteenth-century novelist, whose most celebrated works are *Le Rouge et le noir* and *La Chartreuse de Parme*. The hero of the former novel, Julien Sorel, is a forerunner of the existentialist heroes of twentieth-century French fiction and film.

Jacques Tati (1908-1982): director who has made French comedy all his own in developing the character Monsieur Hulot, seen notably in *Les Vacances de Monsieur Hulot* (1953) and *Mon oncle* (1958).

Bertrand Tavernier (1941-): a director who first worked as critic on *Positif*, Tavernier has produced a very wide corpus of films. His exploration of personal histories through the heritage genre in *Un Dimanche à la campagne* (1984) and *La Vie et rien d'autre* (1989) has been particularly successful. He has also offered more intimate personal histories in *Une Semaine de vacances* (1980) and *Daddy Nostalgie* (1990).

André Téchiné (1943-): one of the finest post *nouvelle vague* directors, particularly adept at showing the complexities of personal relationships as in *J'embrasse pas* (1991), *Ma Saison préférée* (1993), *Les Roseaux sauvages* (1994) and *Alice et Martin* (1998). His take on the *polar* in *Les Voleurs* (1996) is also particularly successful.

Michel Tournier (1924-): contemporary novelist who offers a French version of magic realism. His works include *Vendredi et les limbes du Pacifique* (1967), *Le Roi des aulnes* (1971) (which was filmed by Volker Schlöndorff) and *Les Météores* (1975).

François Truffaut (1932-1984): one of the key directors of the *nouvelle vague*. Truffaut first worked as a critic for *Cahiers du cinéma* and went on to produce a series of personal, innovative and increasingly well-loved films, including, *Les 400 coups* (1959), *Jules et Jim* (1961), *La Nuit américaine* (1973) and *Le Dernier métro* (1980).

Agnès Varda (1928-): the only woman director closely associated with the *nouvelle vague*. Her films are particularly interesting in their treatment of memory and mortality. Her work includes *Cléo de 5 à 7* (1962), *L'Une chante, l'autre pas* (1977), *Sans toit ni loi* (1985) and *Jacquot de Nantes* (1991).

Sandrine Veysset (1967-): young director whose first film, *Y aura-t-il de la neige à Noël* (1996), a bleak tale of rural deprivation and the strong bond between a mother and her children, knew great success.

Jean Vigo (1905-1934): an influential early director, who developed his own version of Poetic Realism. His film, *L'Atalante* (1934), with Dita Parlo, is particularly memorable.

Emile Zola (1840-1902): Naturalist novelist who was born in Provence. His novels have frequently been filmed; a recent example is Calude Berri's *Germinal* (1993).

Eric Zonka (no dates available): new director whose first feature, *La Vie rêvée des anges* (1998), has known considerable success in France and abroad.

Index